DOGS RULE

NONCHALANTLY

DOGS RULE

NONCHALANTLY

By Mark Ulriksen

Published by
GOFF BOOKS

Published by Goff Books. An imprint of ORO Editions
Gordon Goff: Publisher
www.goffbooks.com
info@goffbooks.com

Produced, edited and designed by THWalker/Storiport
www.storiport.net

Written and illustrated by Mark Ulriksen
www.markulriksen.com
copyright © Mark Ulriksen 2014

10 9 8 7 6 5 4 3 2 1 First Edition
Library of congress data available upon request.
ISBN: 978-1-939621-10-8

This book is dedicated to
HENRY, TED, MAGGIE, SABLE, DOOG,
BERNIE, SABER II
BUCK, CLEO, TIGER, SABER
(my dad really liked that name),
and to my parents,
who first introduced me to a world
filled with slobbery kisses and
unconditional love.

When I was a kid I always wanted
a BIG dog, like a Labrador Retriever
or a German Shepherd,
a dog that would fetch balls,
chase squirrels and bark at bullies.

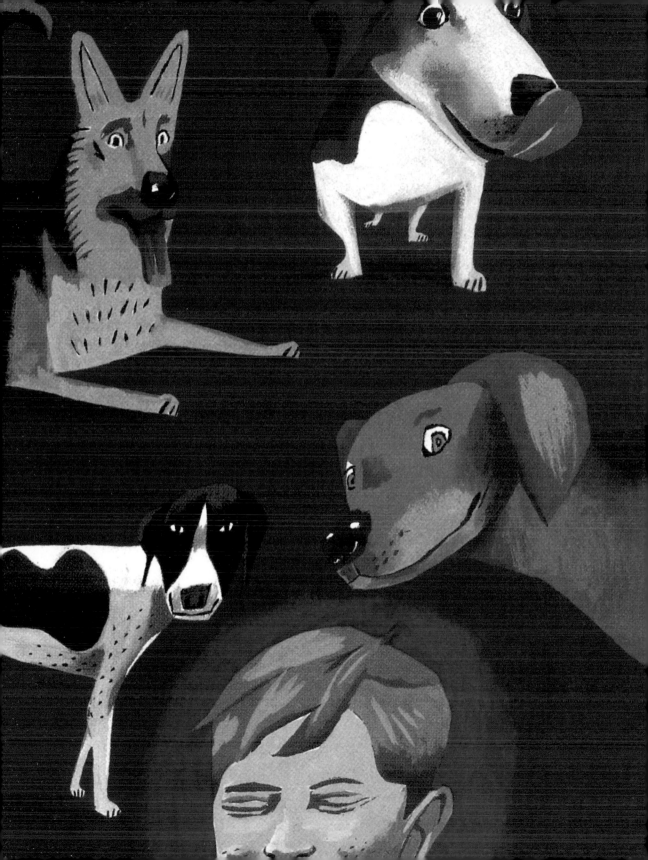

My first dog, BERNIE
wasn't much of a retriever,
and he wasn't very scary.

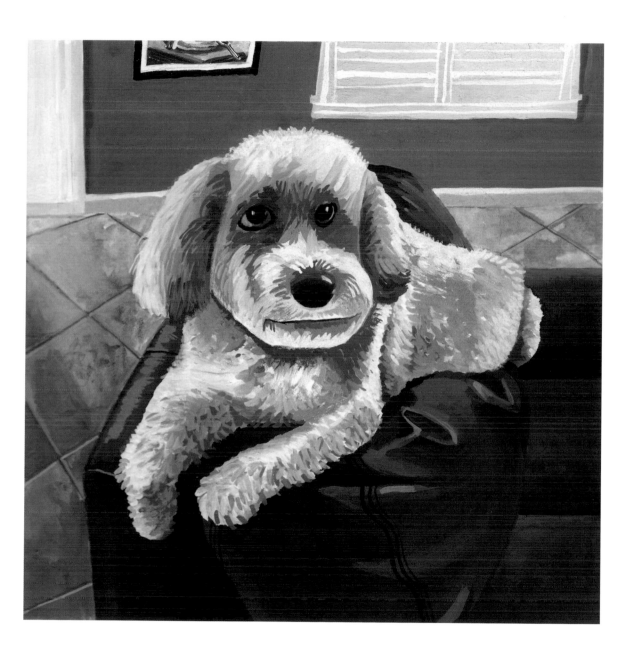

Personally,
I was never big
on little dogs.

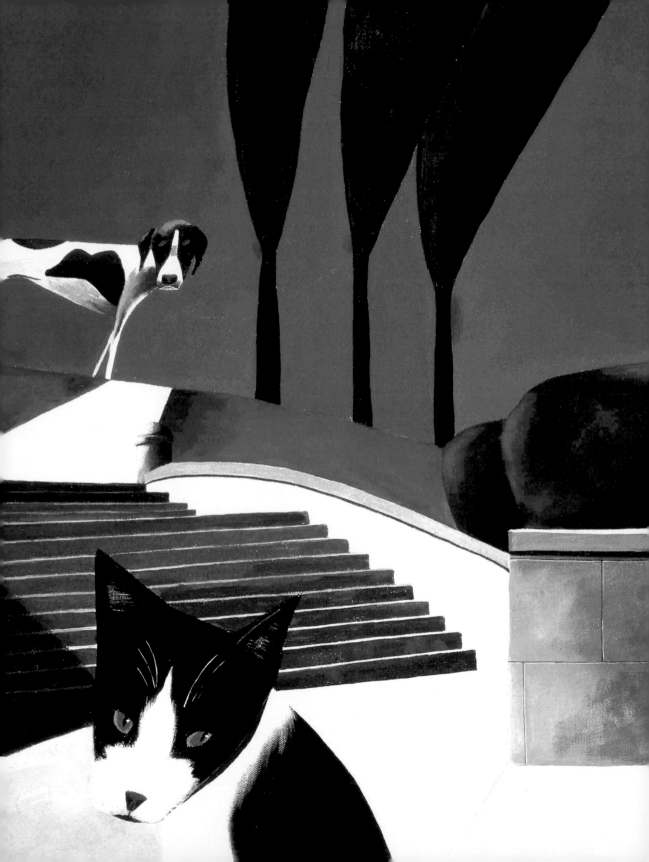

...and cats are
a little too
independent,
too aloof
to get close to.

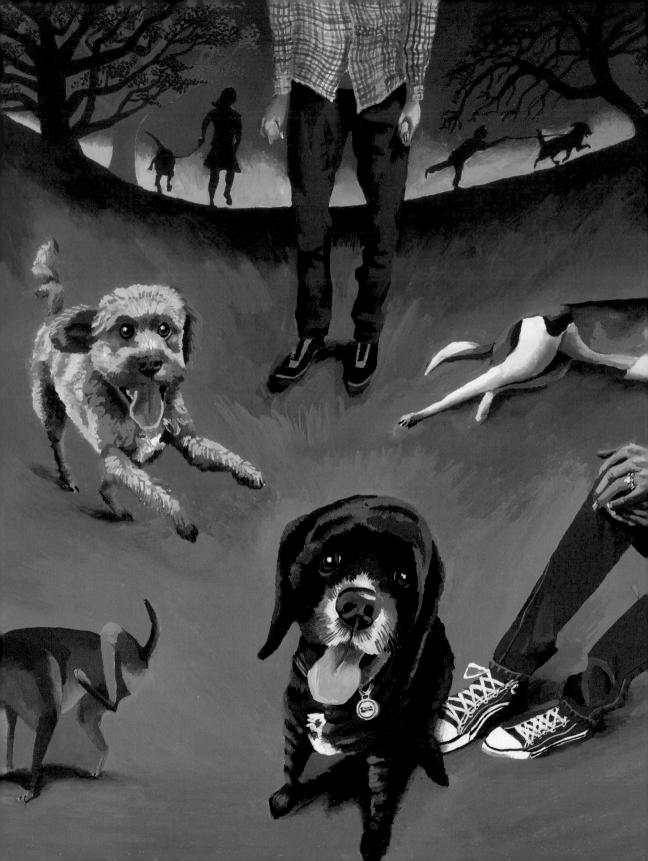

But dogs are different, they give you
their undivided attention. They watch
your every gesture, read your
every emotion, listen attentively
to every word you say—
until they hear the rustle of a bag
of chips being opened.

Dogs are never shy about telling
you when they need something.
Despite their limited vocabulary
dogs are great communicators—
they let you know when they're
tired, hungry, in need of affection
or a bathroom.

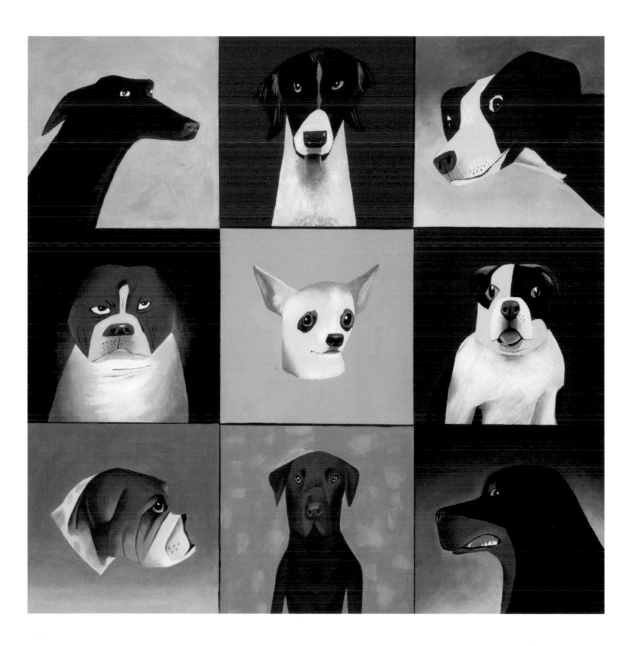

A dog will greet you like
a long lost friend,
jumping on you with muddy
paws, tail wagging, and
a cold, wet nose pushed into
your face or your crotch.

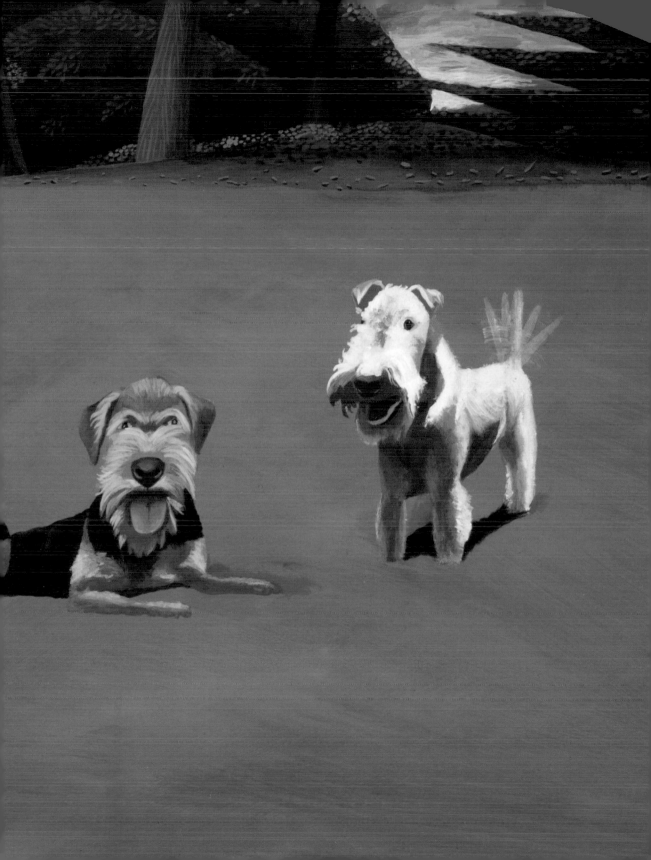

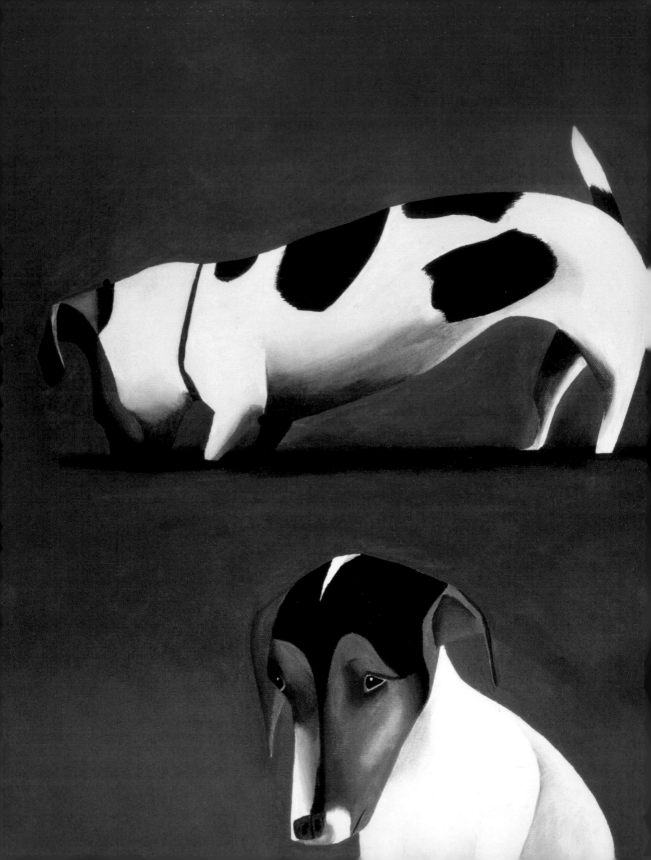

While other times they're having
so much fun sniffing around,
they conveniently forget you even exist.

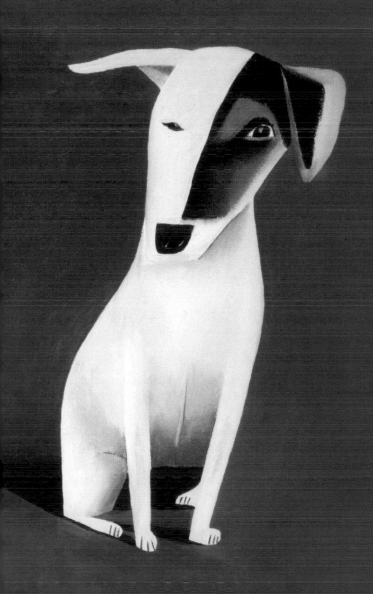

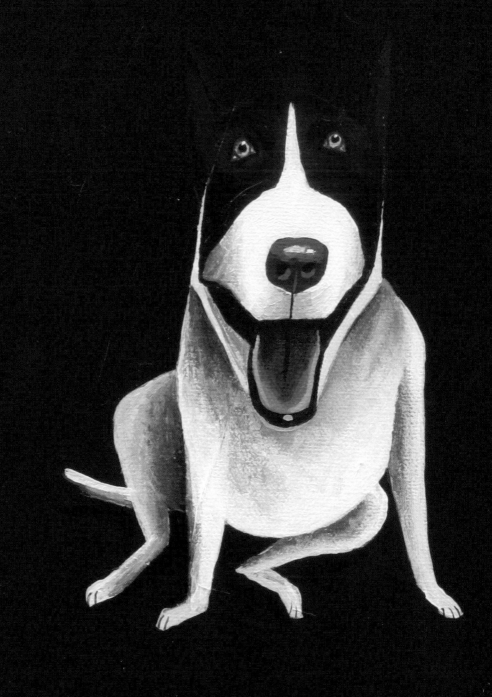

There's nothing happier
than a happy dog.

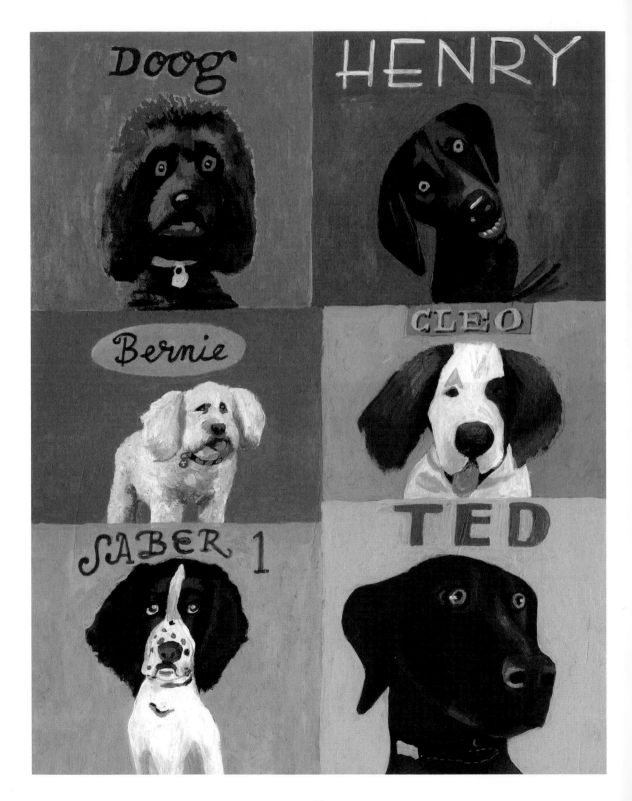

Of course I've been happy with all of
my dogs. Some more than others.

SABER #1 was happiest duck hunting.
HENRY prefers digging up gopher holes.
DOOG had only two personality traits:
overjoyed, as when she was licking
between your toes and depressed,
when she wasn't.
CLEO loved to escape from our
backyard and visit me at school.
TED was a perfect dog: smart,
friendly, and obedient.
BERNIE was a tad too excitable,
so thrilled at mealtime that he'd pee
in his food. BERNIE wasn't with
us very long.

Each of my dogs had their own
favorite meal.

HENRY the chocolate Lab = Bananas
TED the chocolate Lab = Toast
DOOG the Poodle = German chocolate cake
CLEO the St. Bernard = Whole chicken,
 uncooked
TIGER the mutt = Mom's cheesecake
SABER the springer spaniel = Leather

Though I've yet to meet a dog that's
a fussy eater.

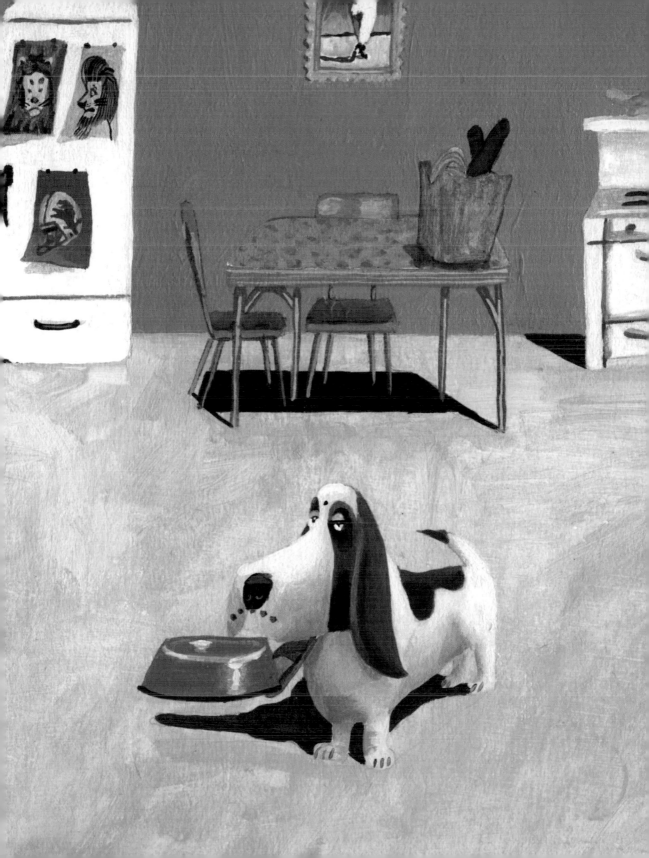

I got my second dog, TIGER,
at a kennel, a full-grown mutt.
While puppies can melt your heart,
getting an older dog does have
its advantages.

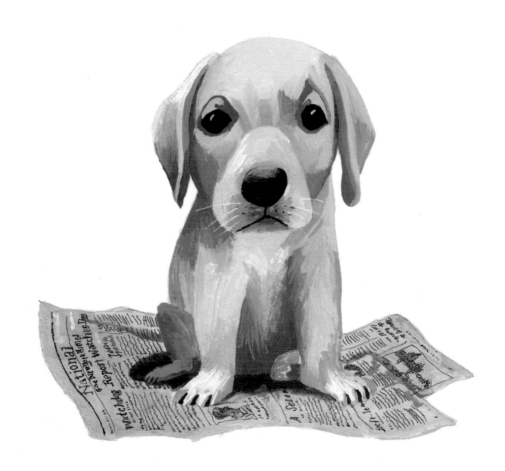

My two retrievers couldn't
have been more different.

TED - Never spent a single night
in a kennel. Too many friends
wanted to dog-sit him.

HENRY - On his first
sleep-over with friends pooped in
their living room, dining room,
and kitchen. Henry has stayed
in many kennels.

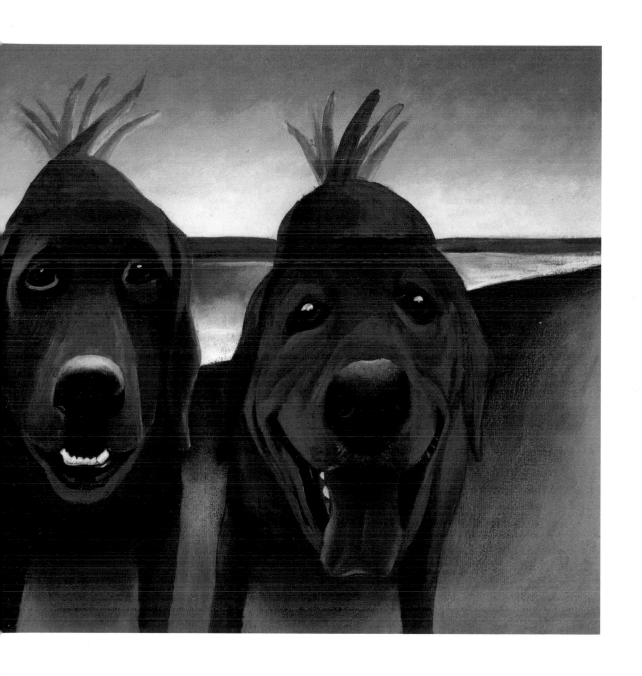

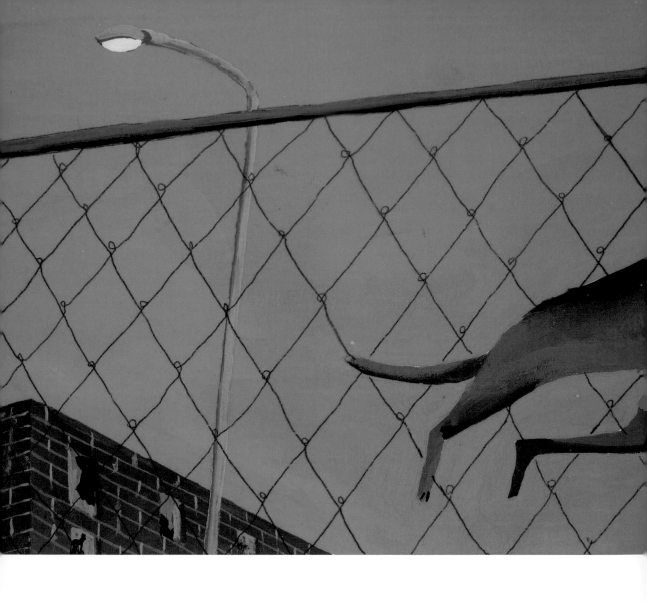

HENRY'S also fussy about what his
paws touch. He's terrified of hardwood
floors. I have to put towels down end
to end to get him to walk to his bed
at night.

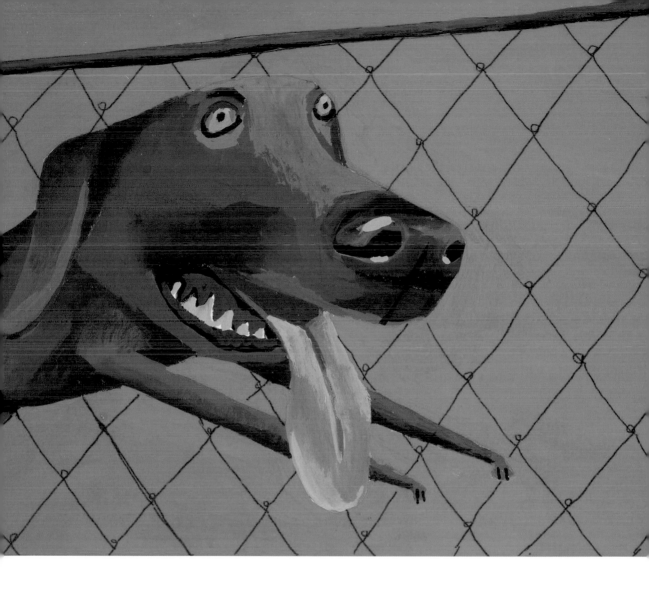

But run through a vacant lot littered
with garbage and broken glass to get
to a dead pigeon? No problem.

dogs are loyal...

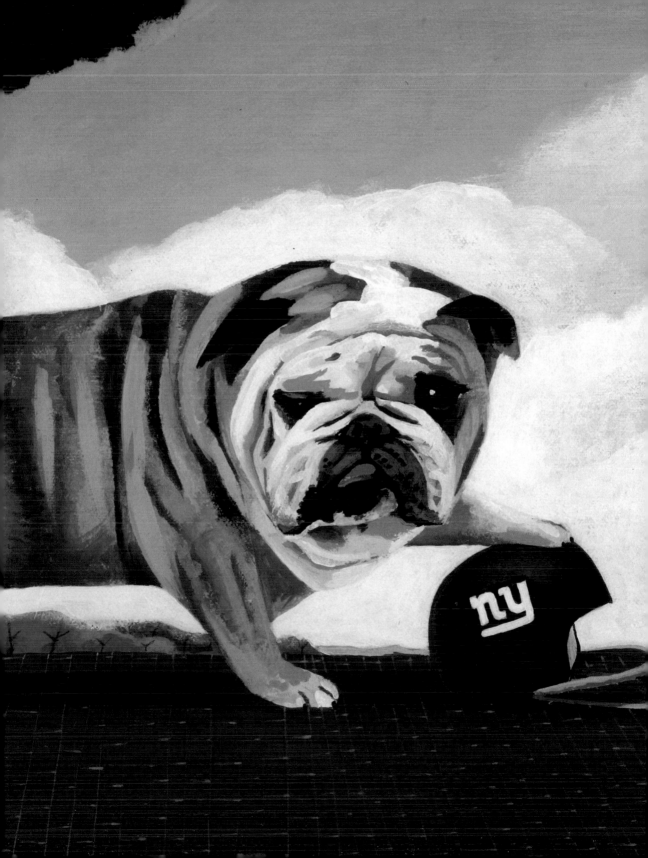

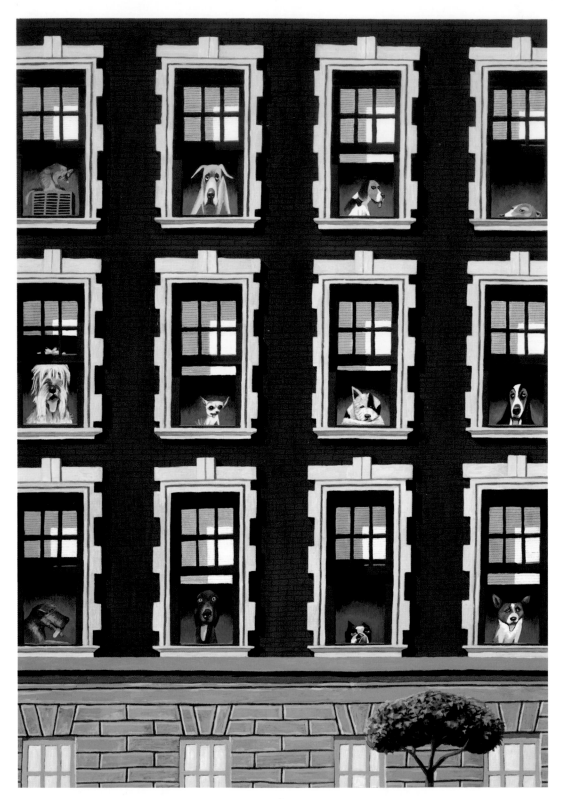

...and patient. Whether you've been gone for 5 minutes or for 5 hours, they'll greet you like you've been gone for 5 years.

NOT that dogs are perfect, mind you.
When I had a paper route as a kid,
I was once knocked clear off my feet
by a charging dog who hit me from behind.

As I lay shocked and sprawled on the
sidewalk with my newspapers scattered about,
the dog gave me a big smile, wagging his
tail feverishly. He just wanted to say hello.

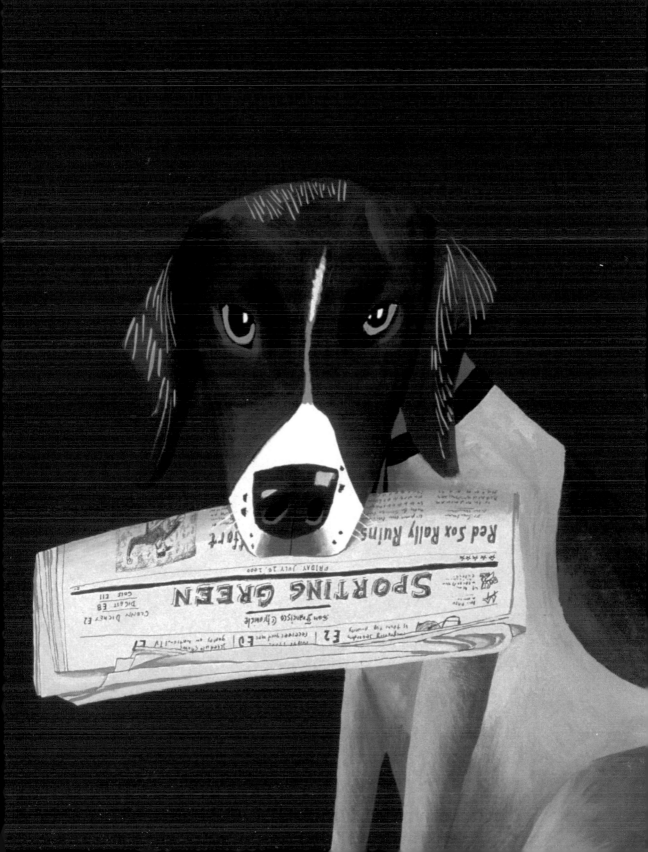

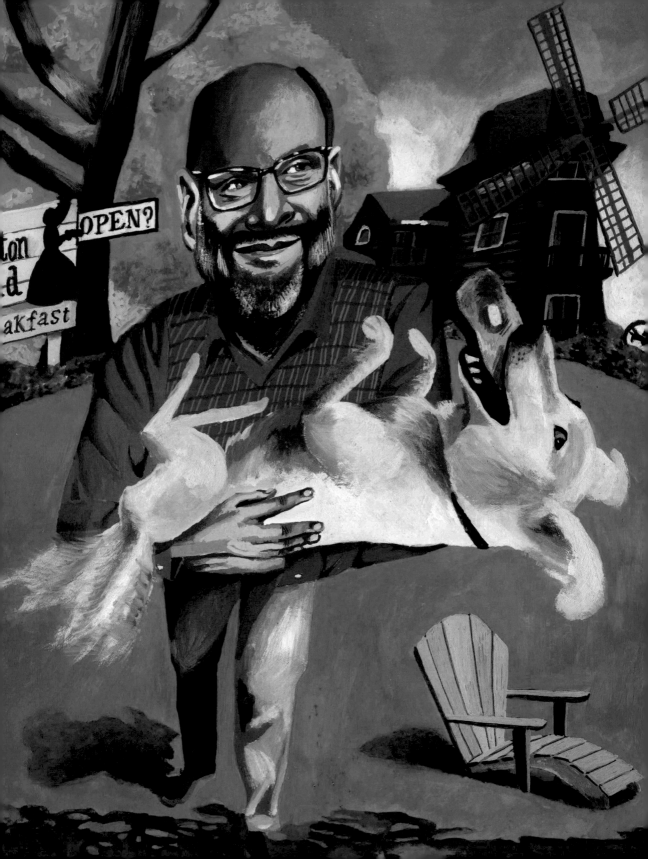

A Dog will stick with you wherever you go, Sorta like velcro.

There's a reason they're called
MAN'S BEST FRIEND.

When I decided to become a freelance
illustrator 20 years ago, I left the world
of co-workers behind me. It was strange
to be working at home, but I wasn't lonely.
I always had my buddy TED by my side.

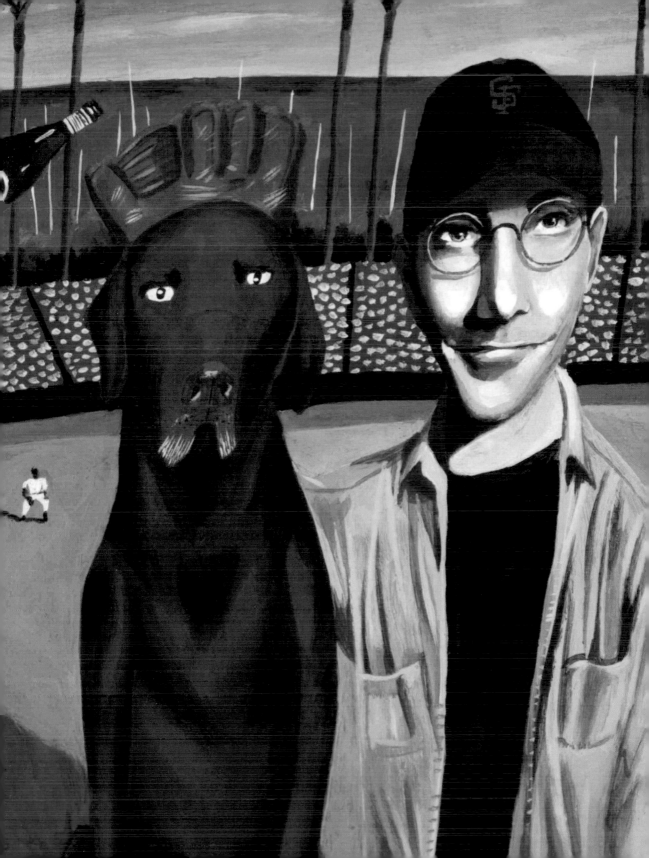

I took TED to puppy classes where
we learned the command "OFF!"
It's a dynamo of a word. You can use
it for any occasion.

Dog eating poop out of a catbox again?
"OFF!"

Gnawing on the couch?
"OFF!"

Humping the neighbor's leg?
"OFF!"

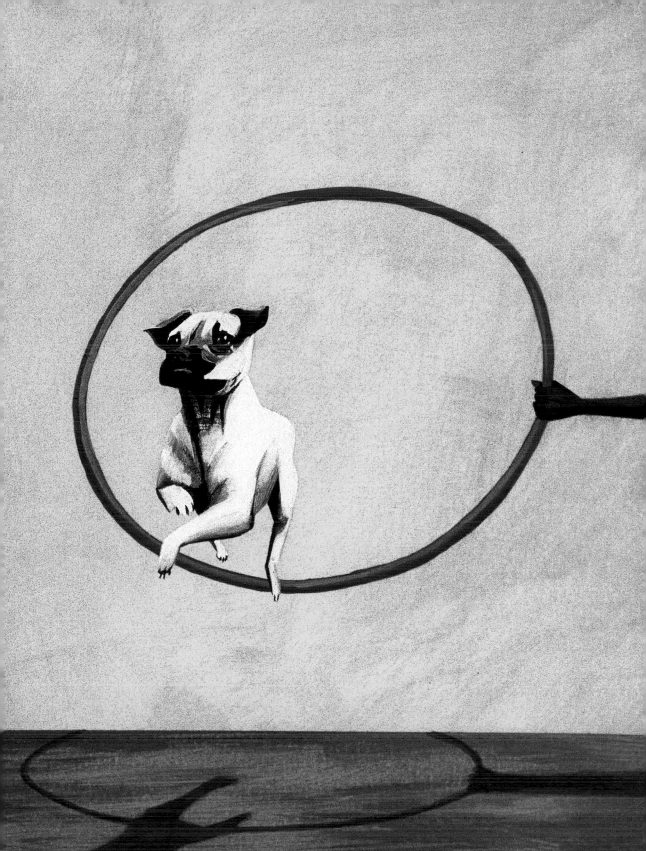

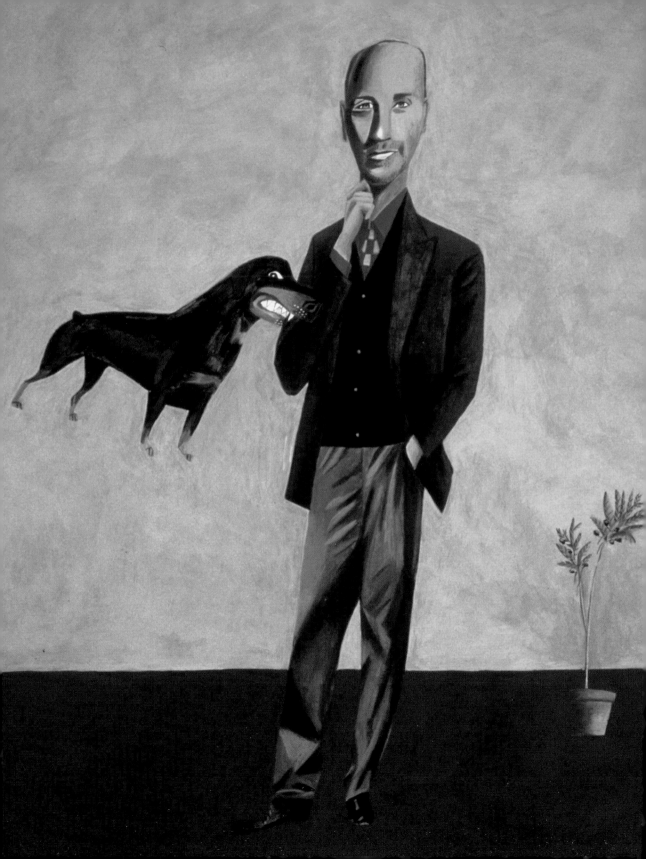

We also learned that a properly trained dog will do whatever you ask and never complain.

Of course few dogs are truly proper.

For Example

Dogs like to chew things.

Dogs like to chew things that belong to others.

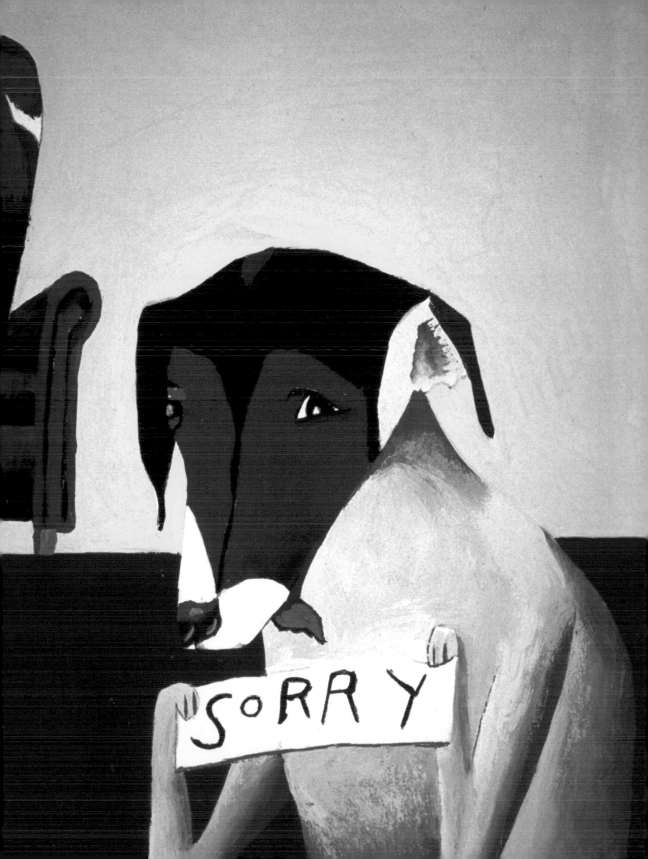

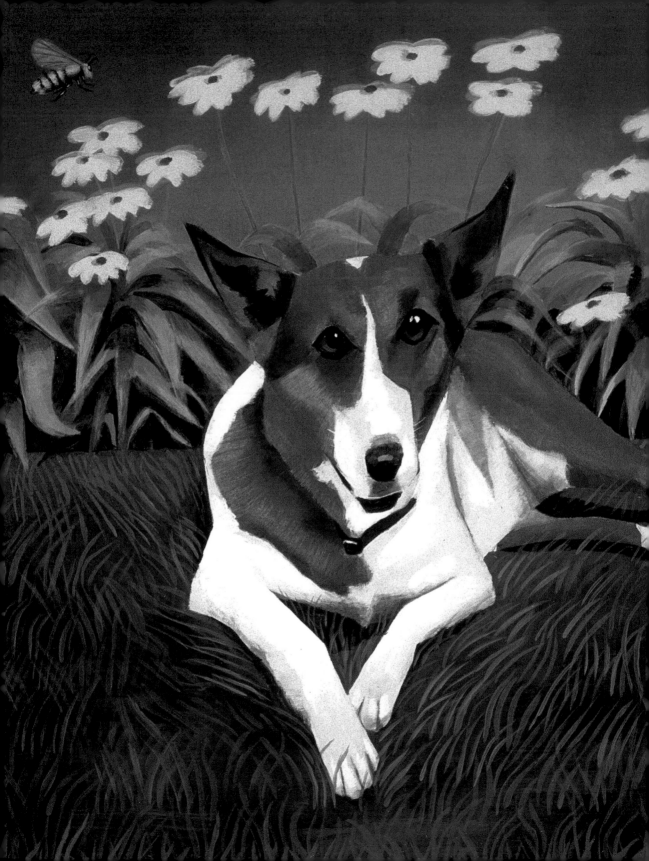

Every Dog has its
own personality
and temperament.
Some dogs learn
quickly how to behave.

Some are just plain stubborn...

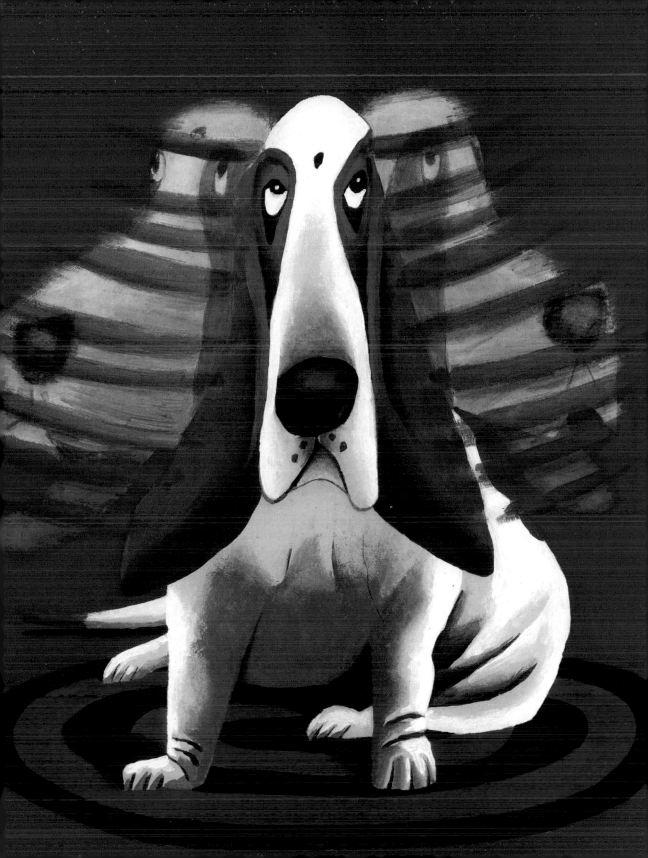

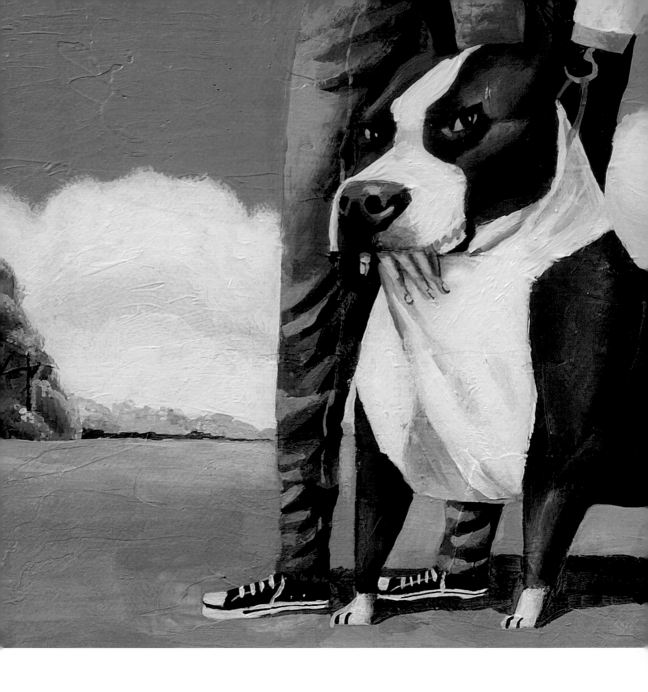

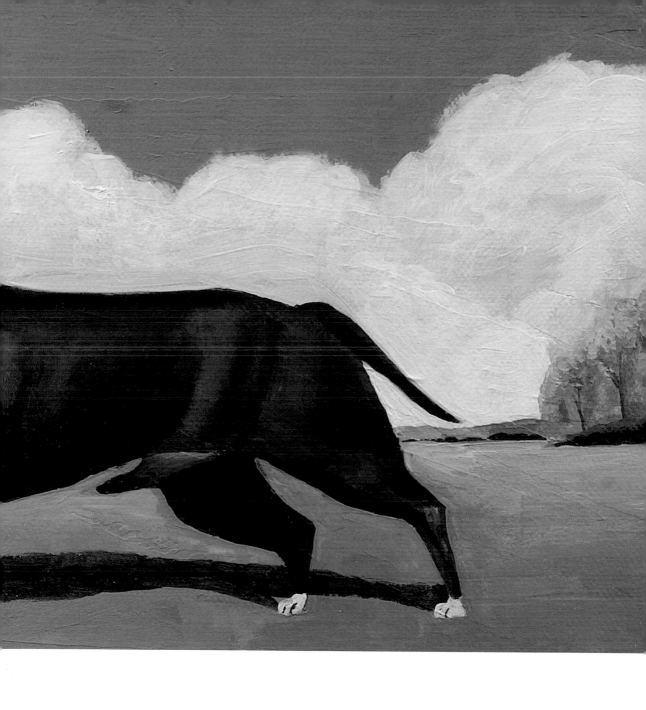

...and some never learn.

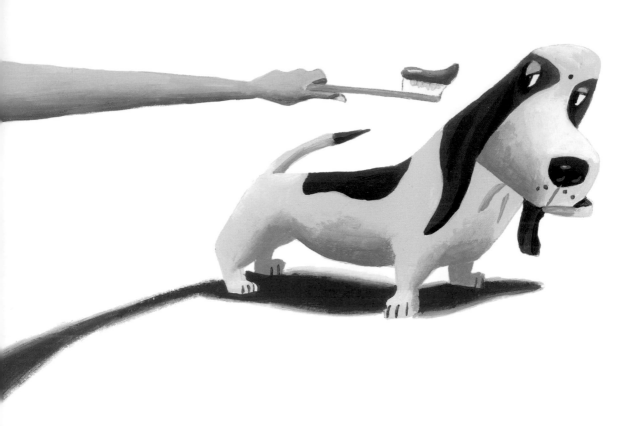

And with all dogs, there's
the maintenance, the brushing...

...and the grooming.

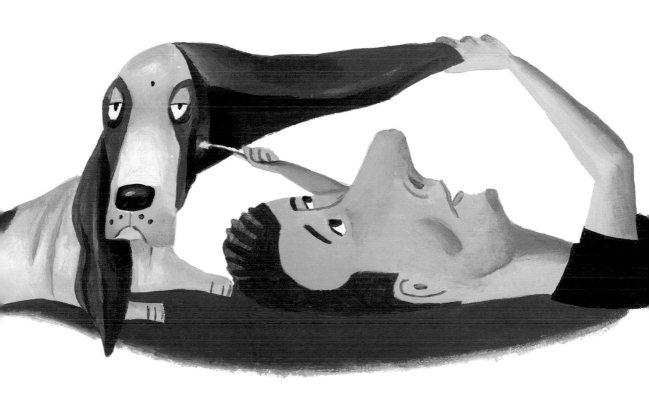

Dogs are clever. They eat well and never do the cooking.

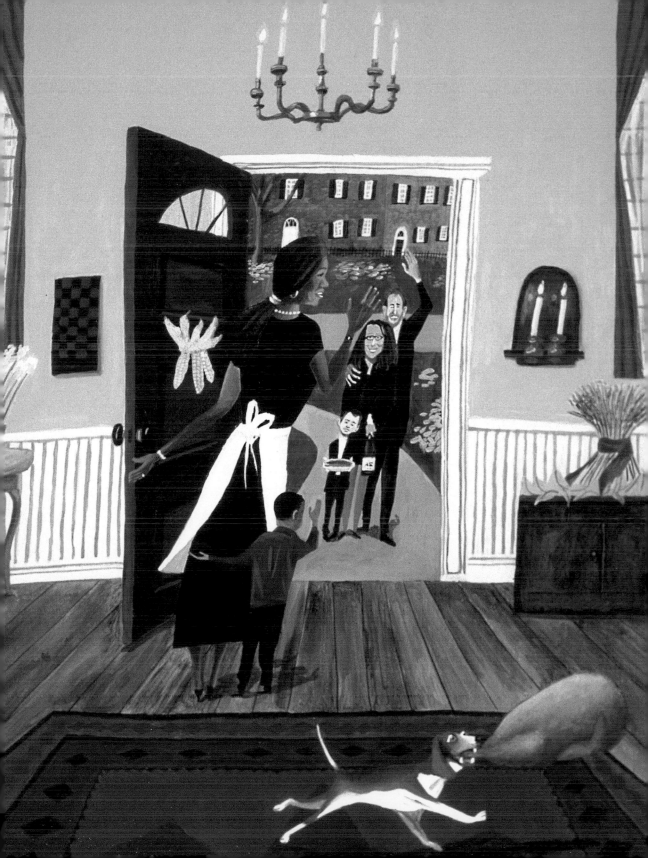

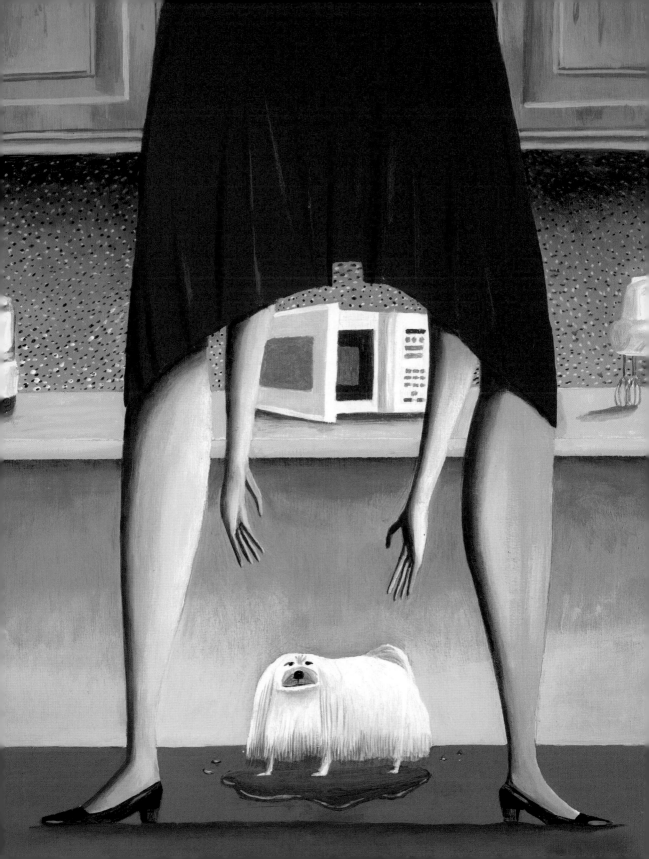

They're smart enough to know what NOT to put in the microwave.

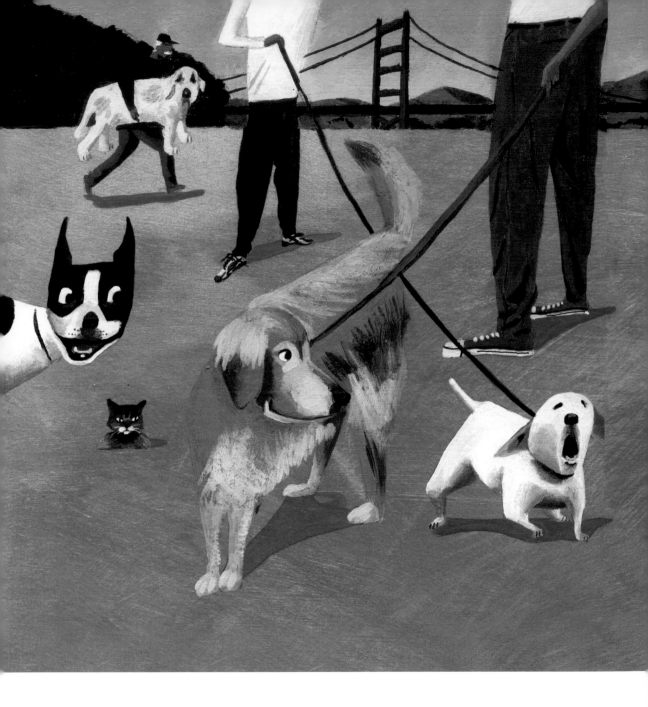

Dogs are a sociable lot. They like getting out of the house, going for a walk or a run.

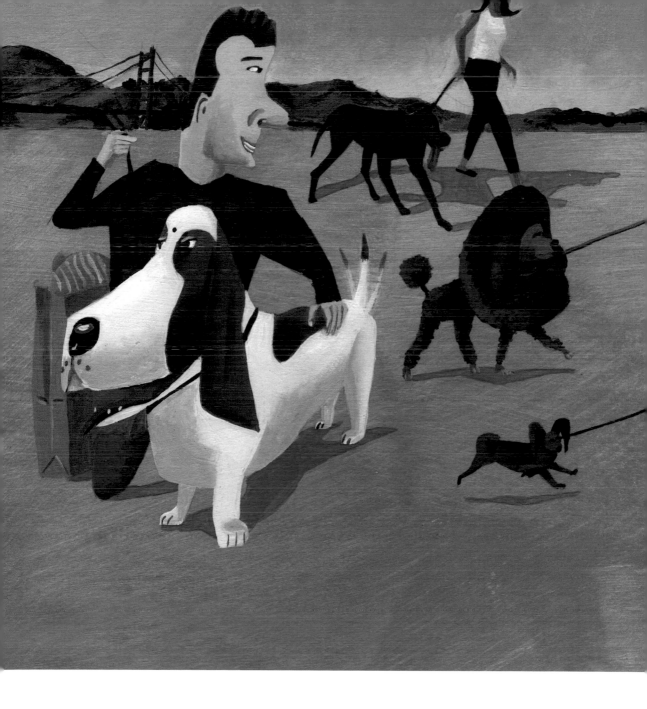

They'll dart across a busy street to greet a stranger.

Dog lovers tend to
favor certain breeds.
My daughter Lily once
wanted a little dog,
like a Dachshund
or a chihuahua.
I preferred big breeds
like Labs or Great
Danes. At the local
Shelter we managed to
find the best of both.

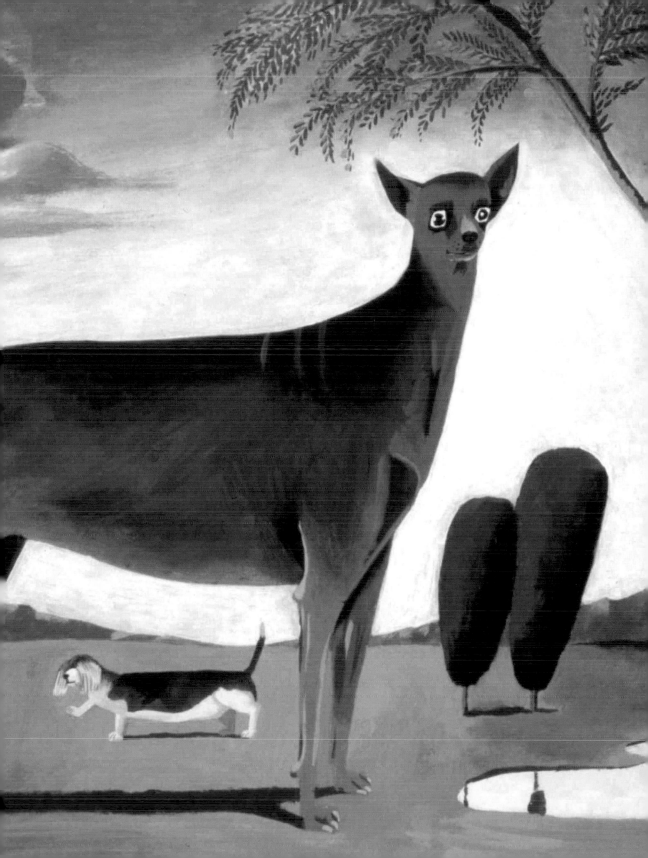

Dogs like to hang with people,
as well as with their own kind.
They don't discriminate between
the mongrel and the purebred.

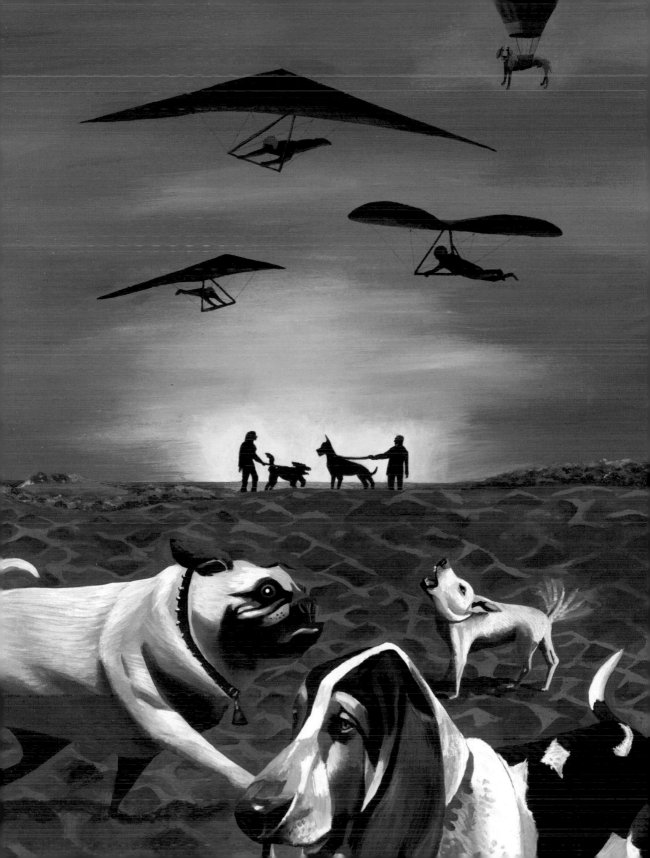

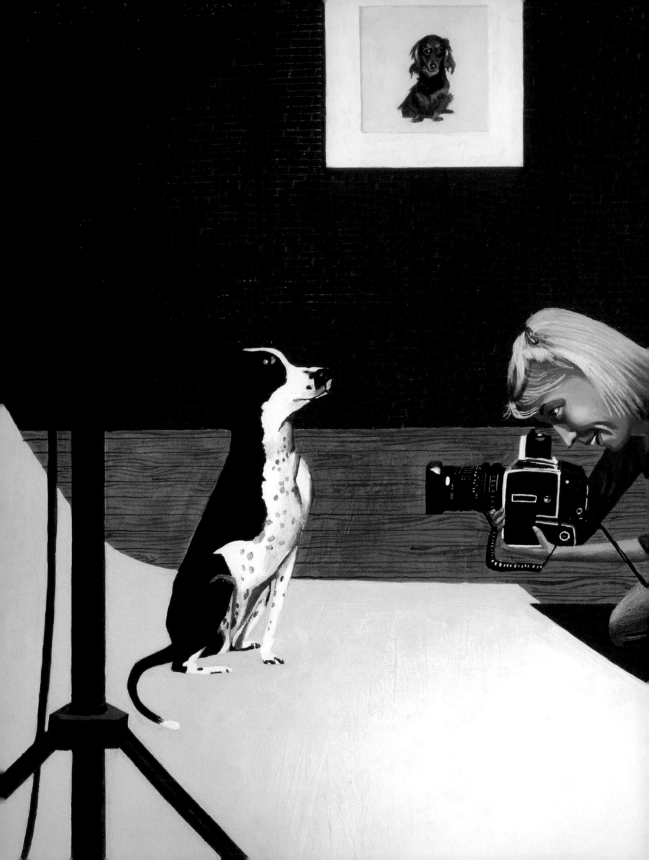

They love attention, and
they're not at all concerned
with their own appearance.

But they don't like being ignored!

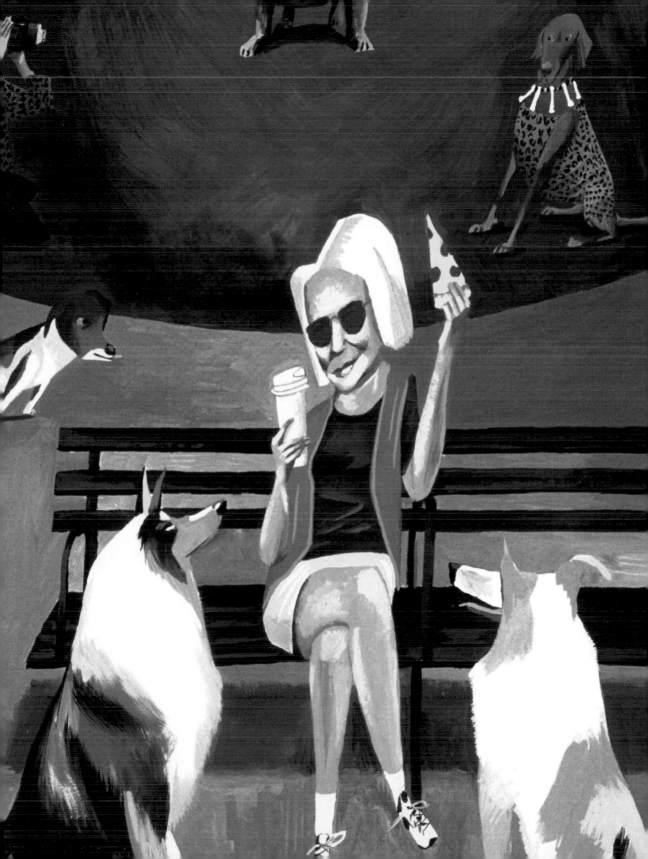

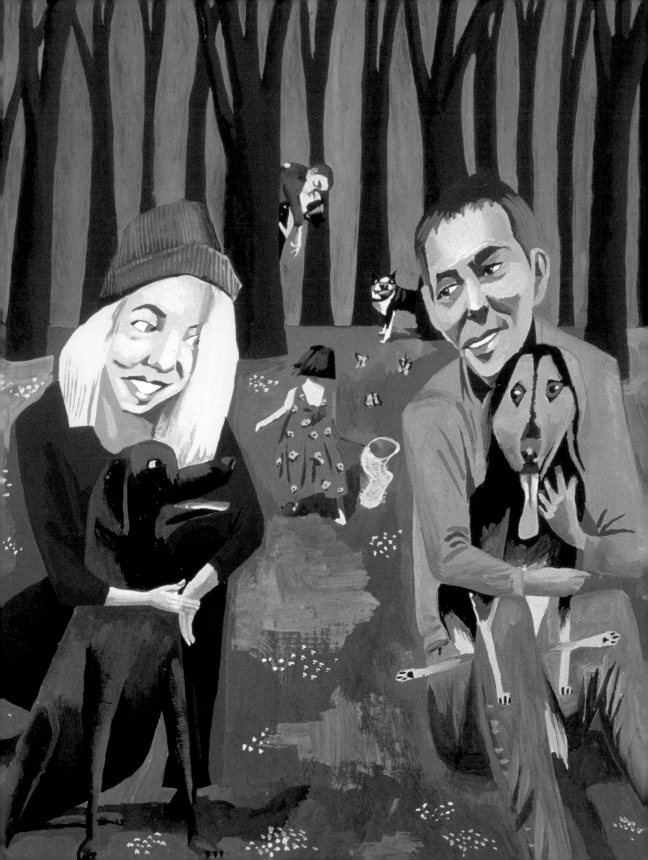

Dogs are an excellent way
to meet the ladies,
or gents.

Dogs are great at getting you out
of the house for some fresh air.

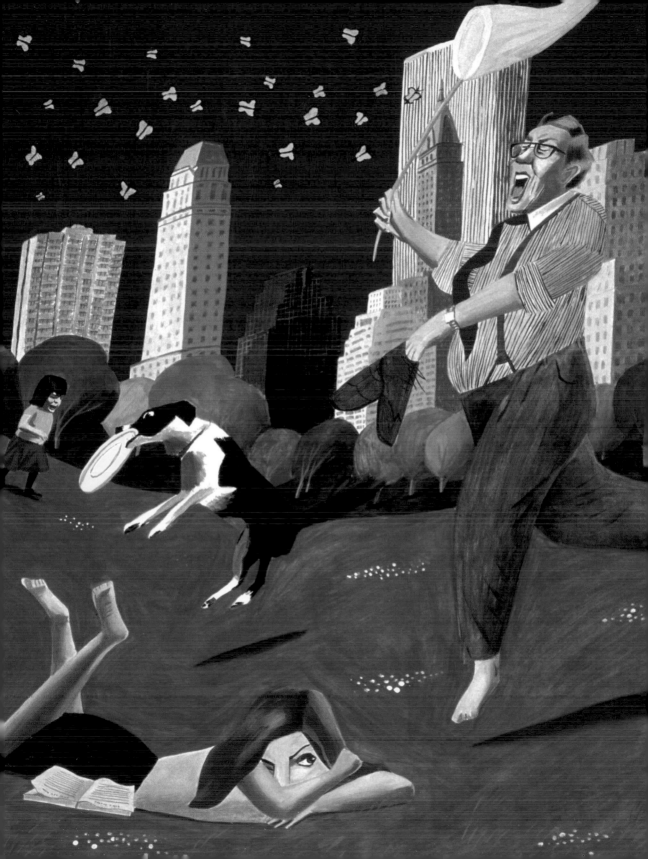

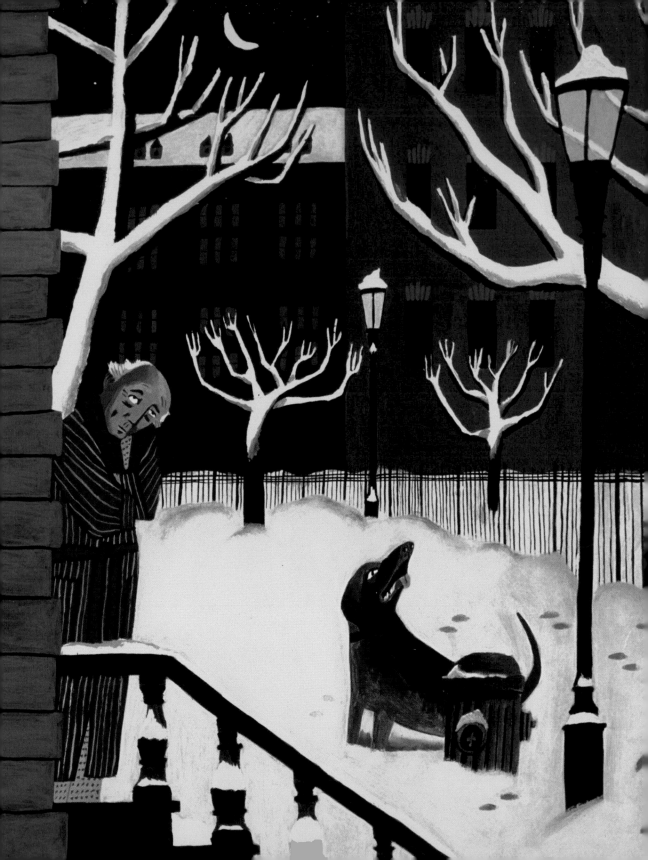

Dogs are great at getting you out
of the house for some fresh air.

of course they need lots of
exercise. And some can use
a little therapy too.

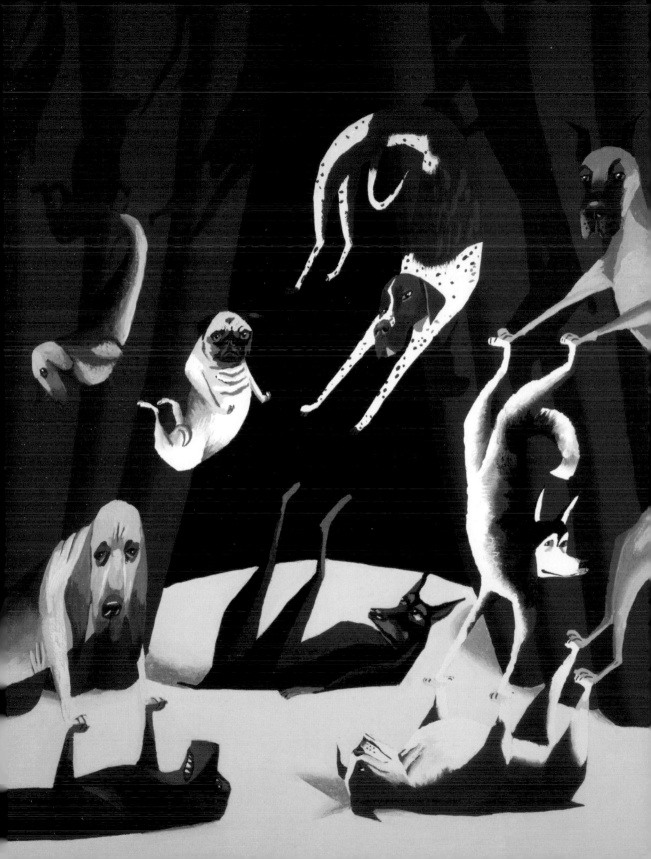

A typical dog 12-step program:

1. Wake up, stretch
2. Eat meal in three seconds
3. Go outside, pee, walk, poop, walk, pee, smell everything
4. Go inside, follow human's every movement, check all floors for microscopic food particles
5. Nap
6. Repeat steps 1-6

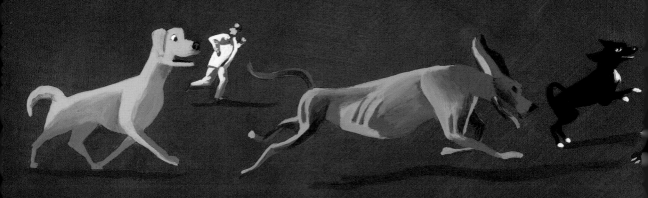

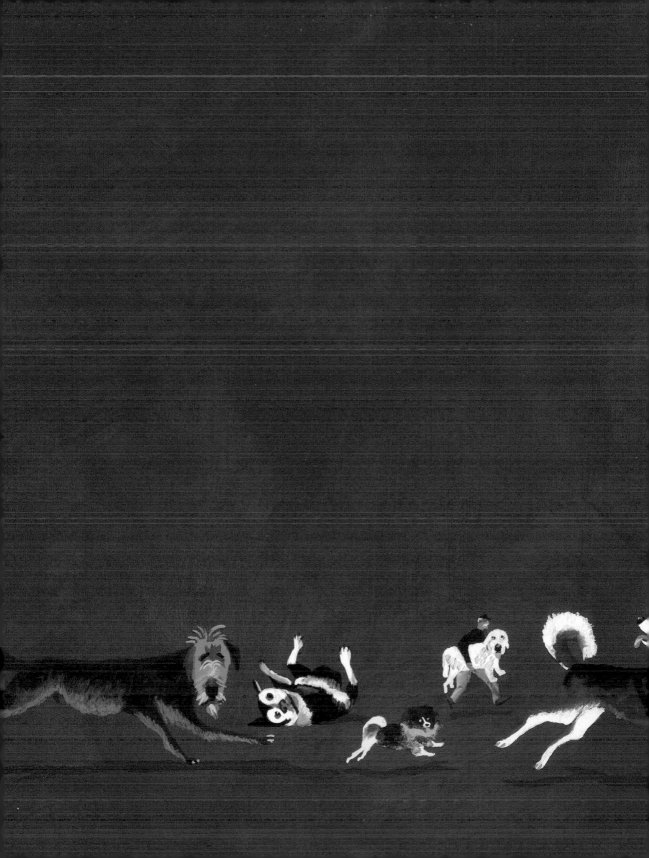

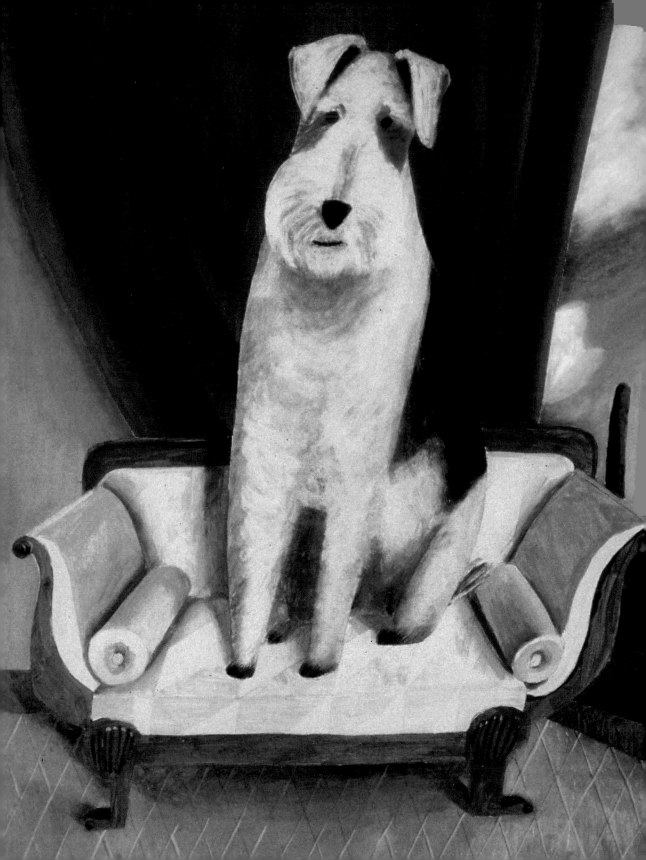

Dogs are seldom unhappy,
until you leave without them.

And if you want to see pure, unbridled enthusiasm, shake the car keys, rattle the dog bowl, or grab a leash.

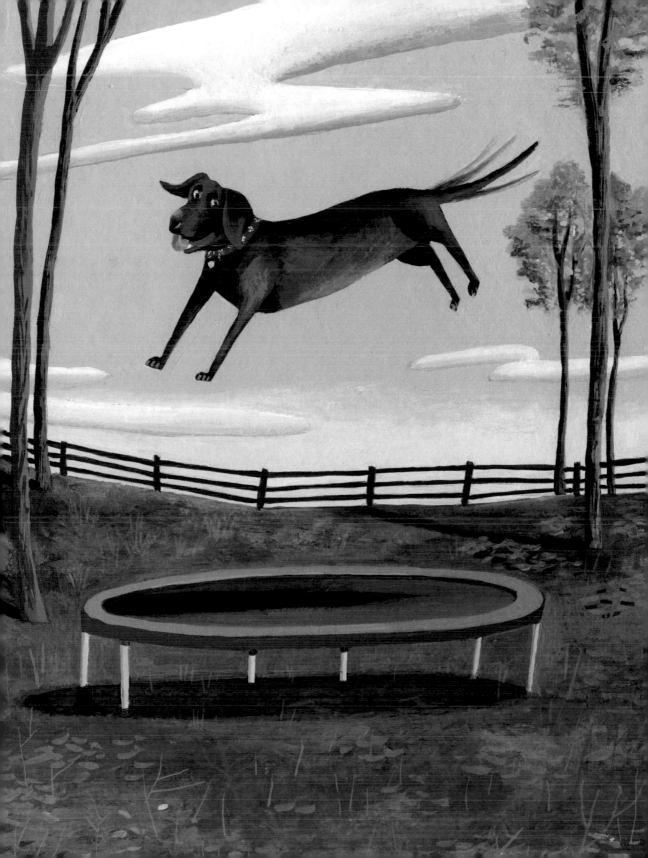

That being said,
certain words
are so powerful
they must be used
judiciously. Words
like W-A-L-K
and P-A-R-K.

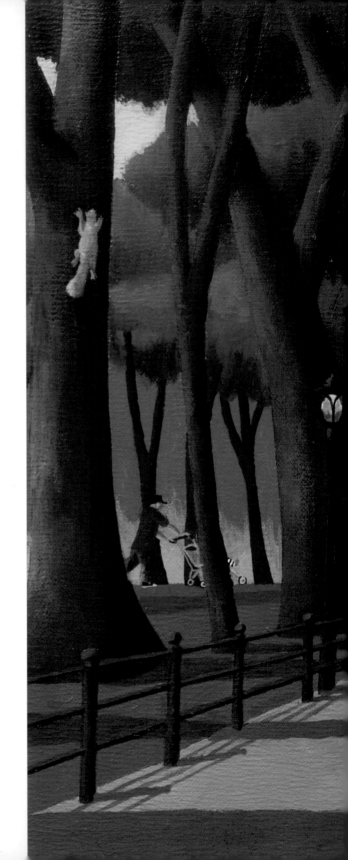

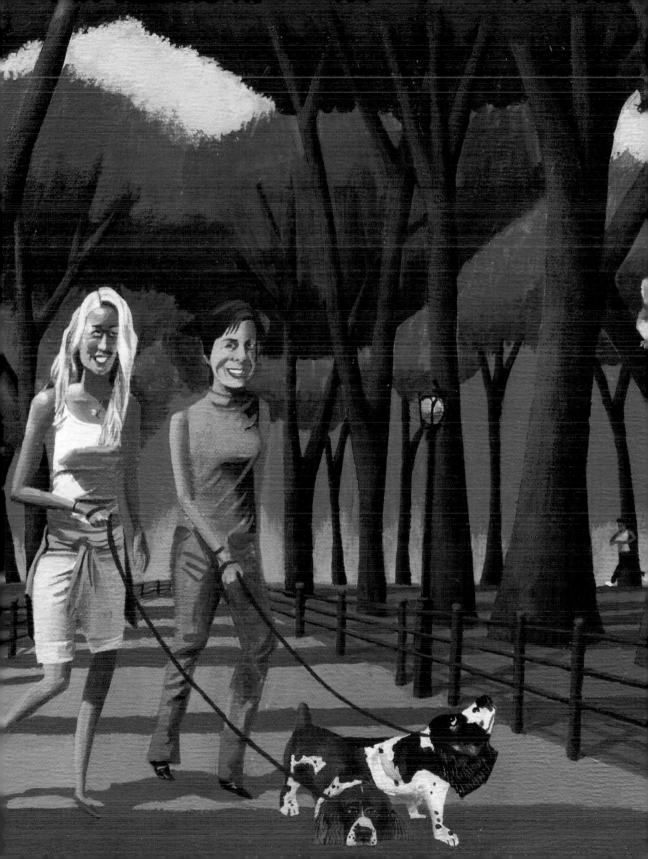

Dogs make you stop
and smell the roses...
and violets...
and daisies...
and tree trunks...
and rocks.
well, just about
everything.

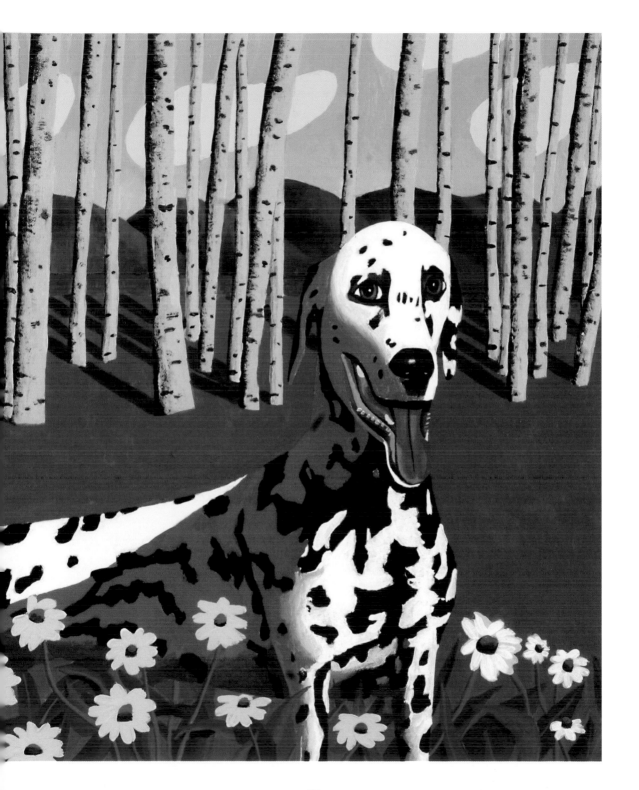

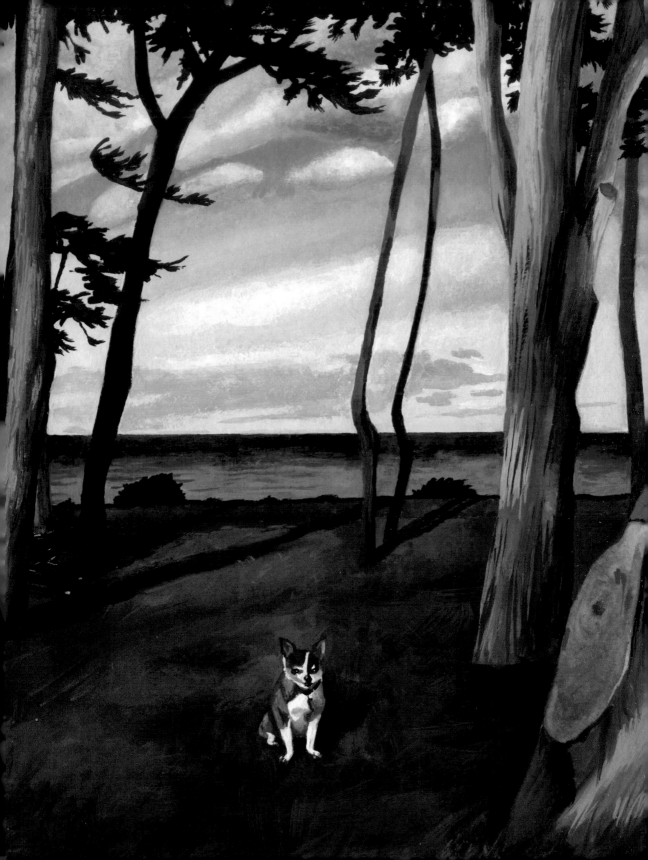

Especially older dogs. Taking them
for a walk is less about exercise
and more about exercising patience.
It's sort of like being stuck in
rush-hour traffic, lots of stop-and-go.

All a dog
needs is
a good stick...

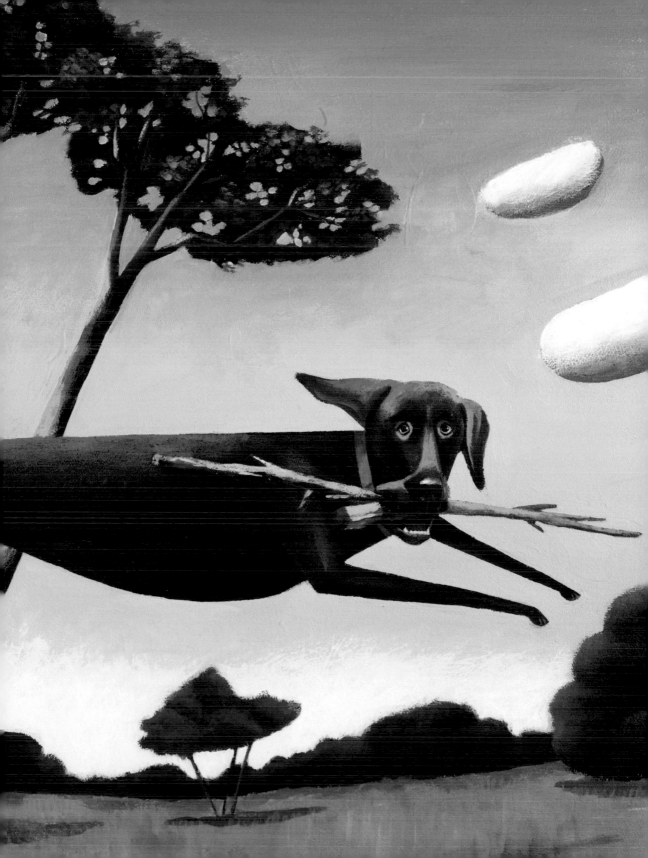

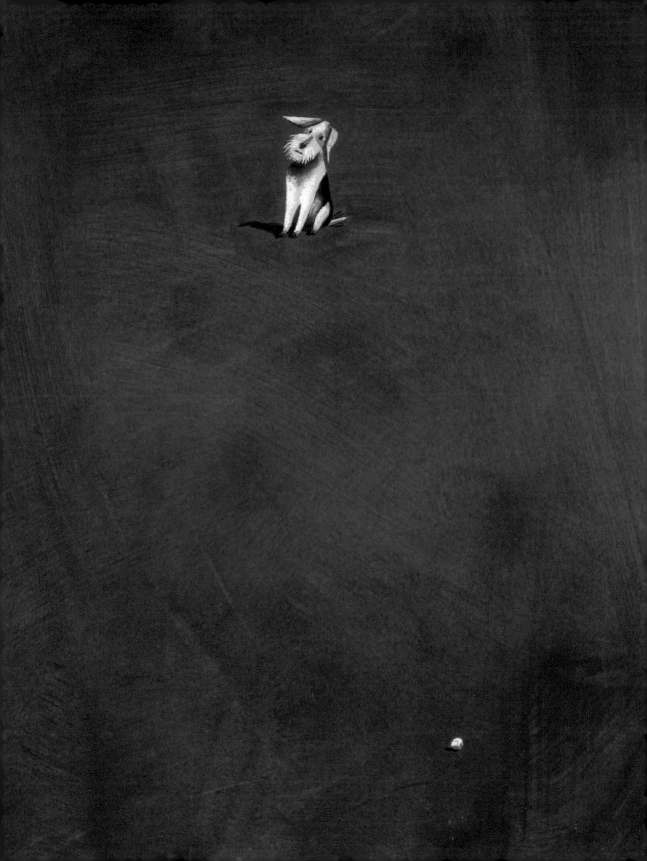

...or a ball.

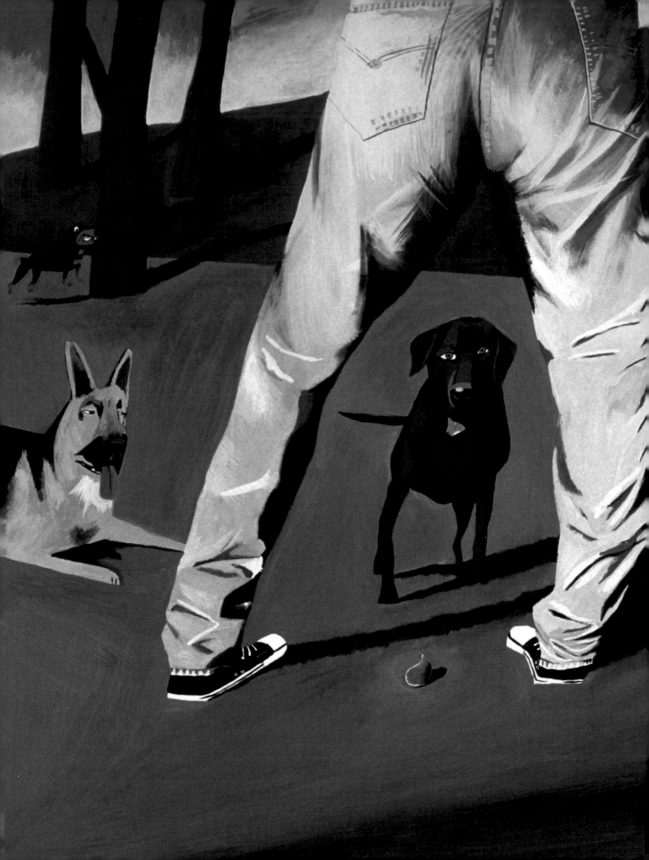

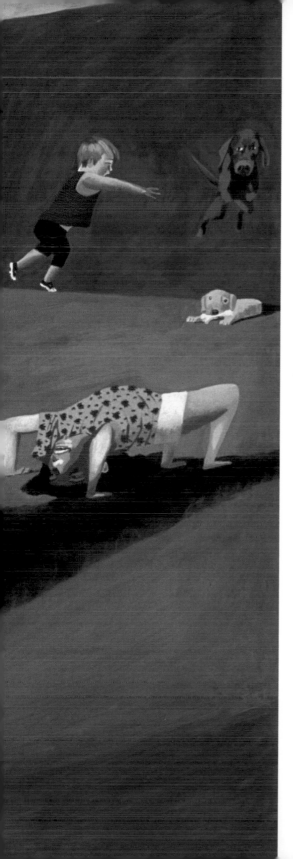

certain breeds find
tennis balls irresistible.
Especially retrievers.
TED would chase them
until my arm gave out.
Then he'd run over to
a stranger, drop a
barely recognizable ball
at their feet and bob
his head up and down,
between the startled
stranger and the slimy
ball, barking non-stop.

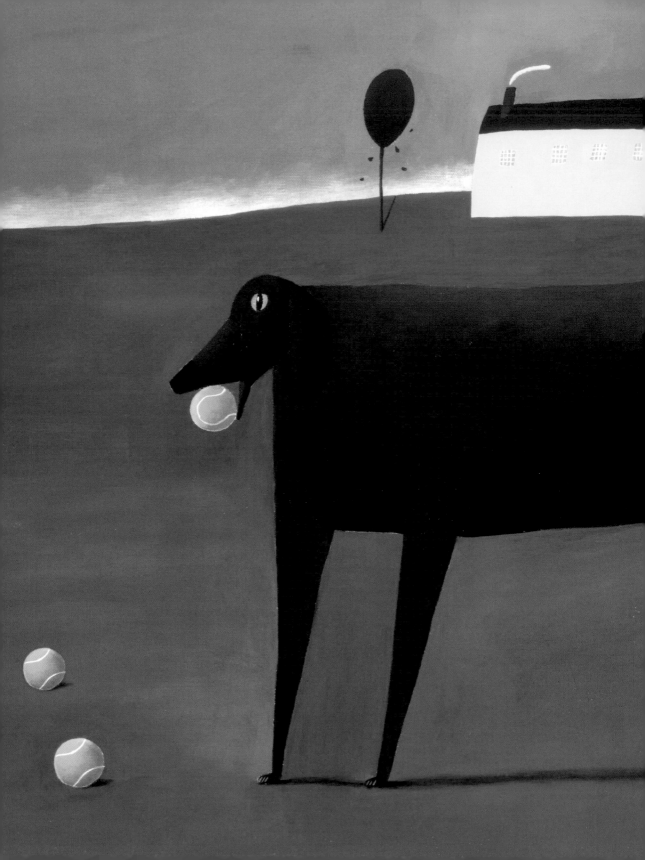

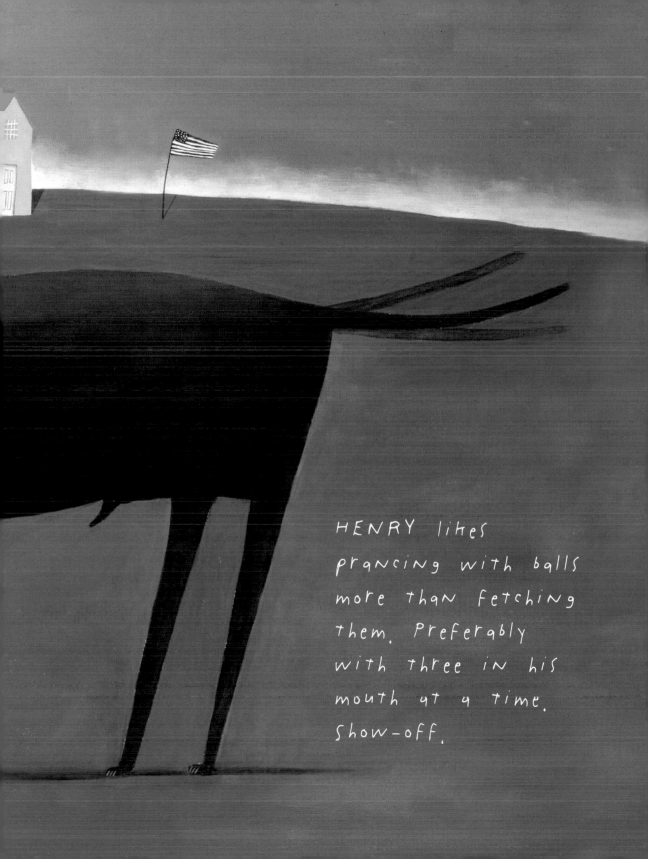

HENRY likes prancing with balls more than fetching them. Preferably with three in his mouth at a time. Show-off.

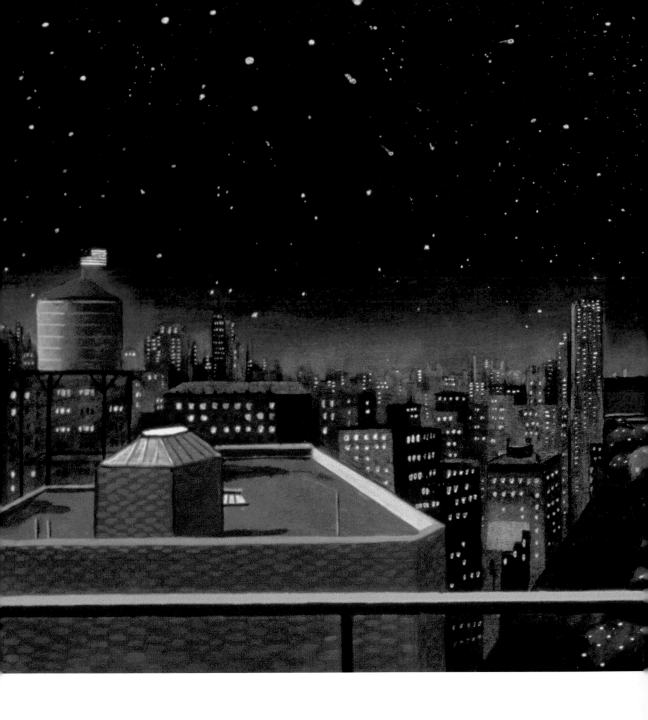

Sometimes, I think dogs
see balls everywhere.

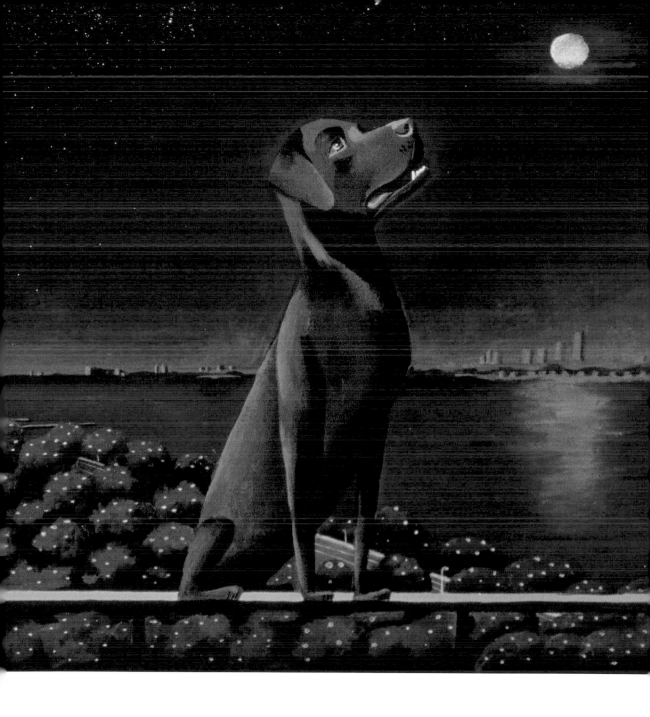

Most dogs LOVE the great
outdoors. SABLE loved
road trips, hanging her
head out of the window
of a speeding car, racing
into icy water,
and peeing on national
monuments.

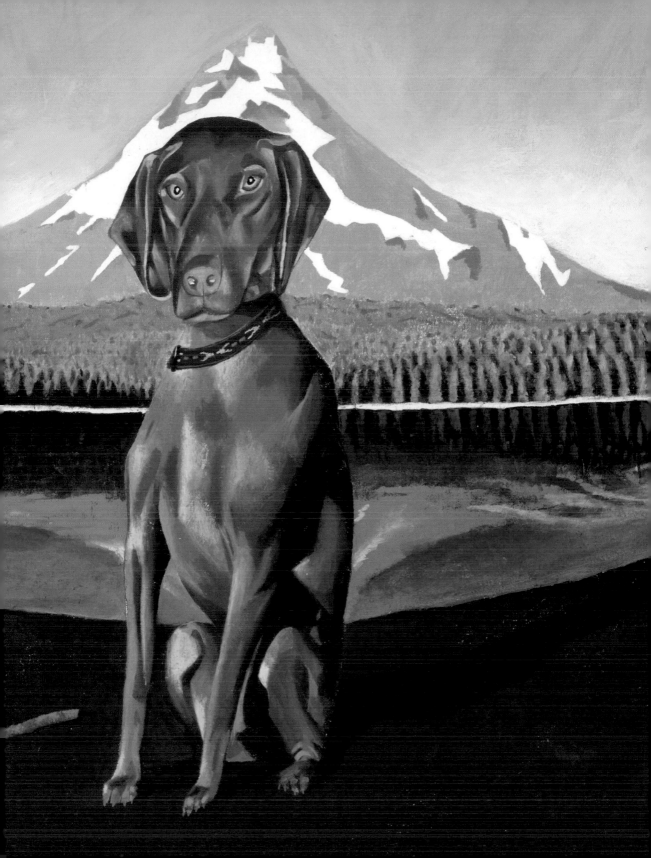

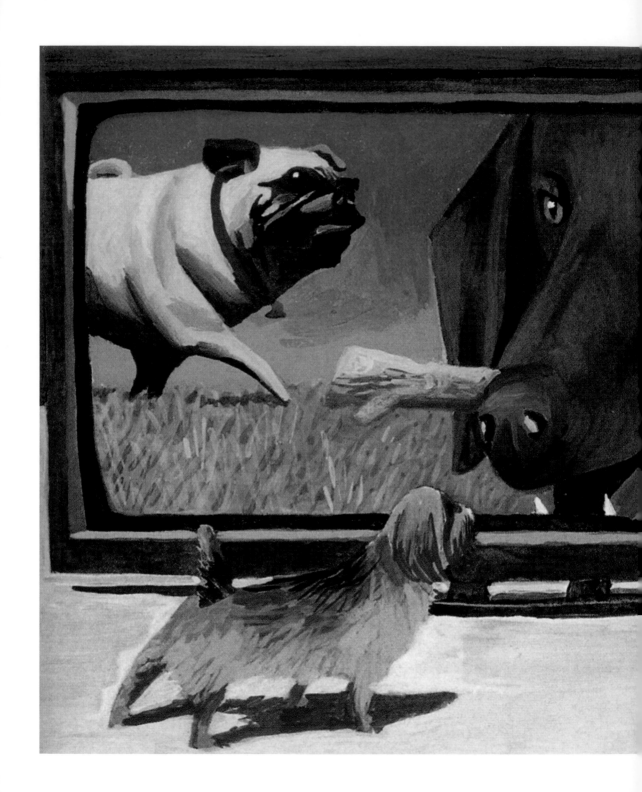

104

BUCK preferred
the great indoors.

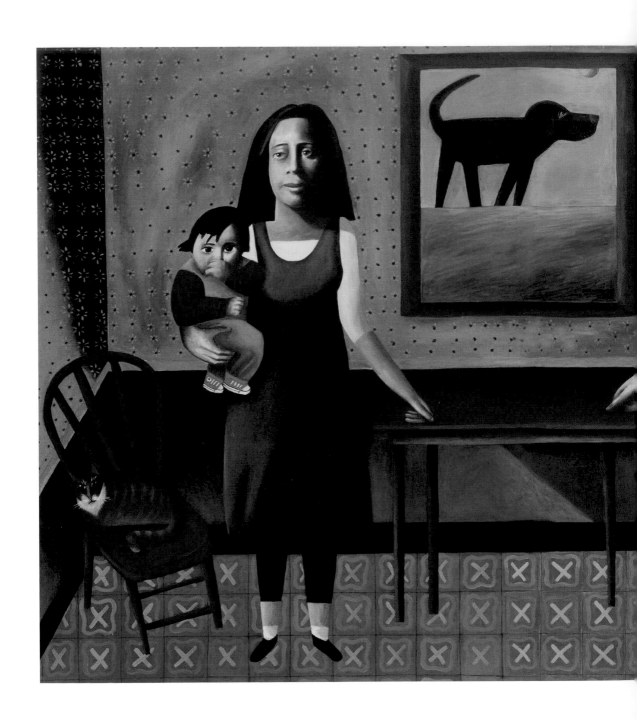

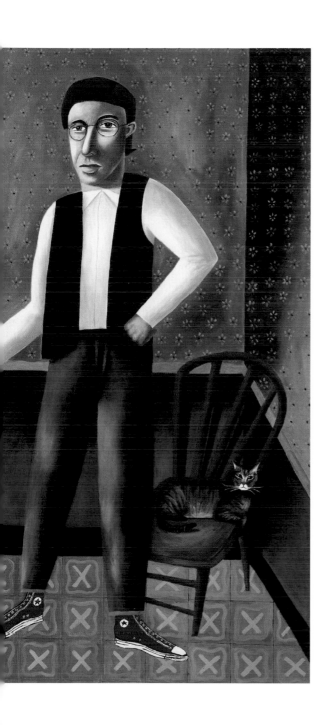

When I married my
wife leSlie, we got
TED as a test.
could we be responSible
for another living
being? We then added
two cats to our
family, which is almost
like one dog, and
then we had a child.

All of a sudden our dog
was no longer the center
of our universe.
But we were still the
center of his.

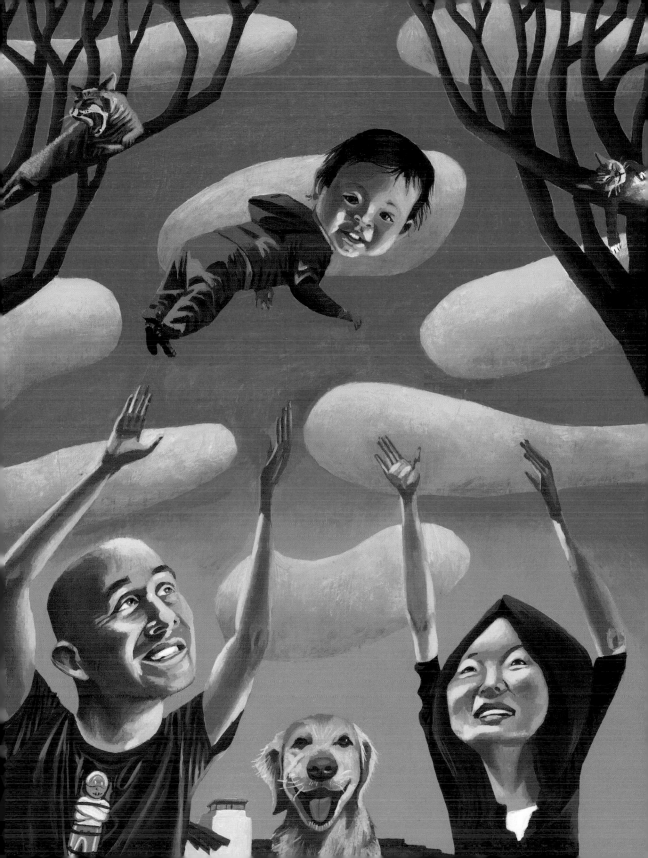

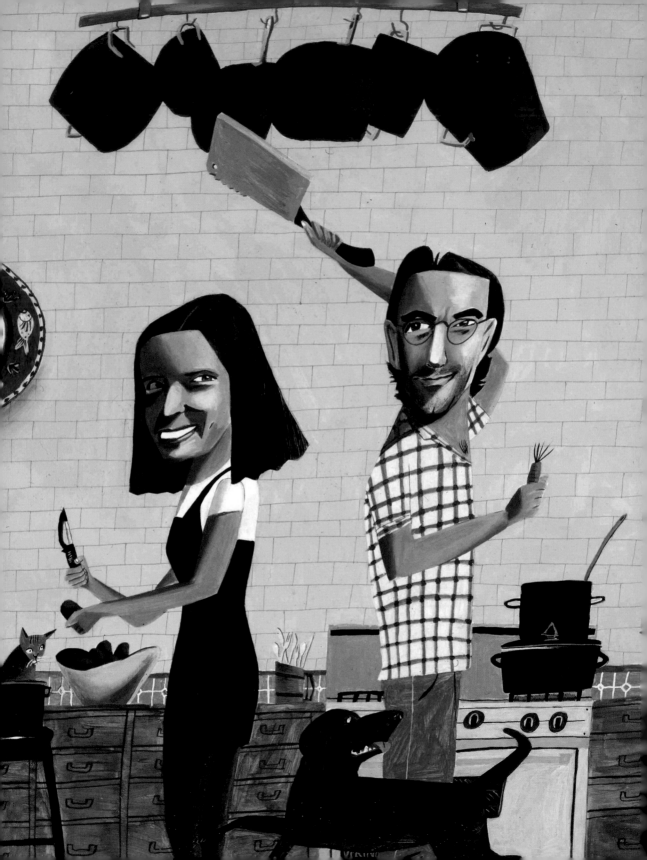

Having a dog around little kids is very practical. You have an auxiliary vacuum cleaner, broom and mop, all in one. No crumb, morsel, or spill goes unattended.

Like kids, dogs grow up fast.
only faster.

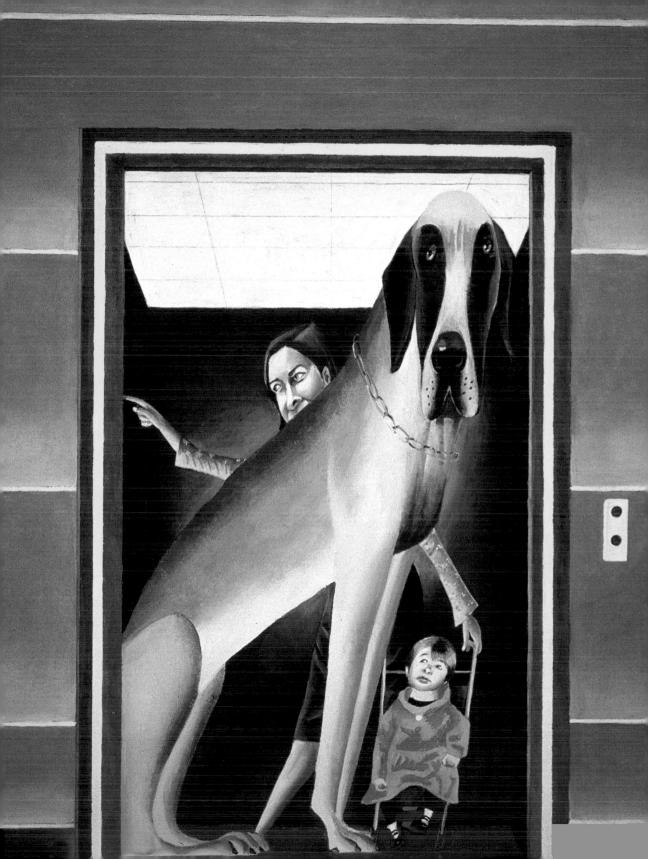

Why teenaged dogs are better than teenaged kids:

1. No eye rolling
2. No snotty remarks
3. No car keys

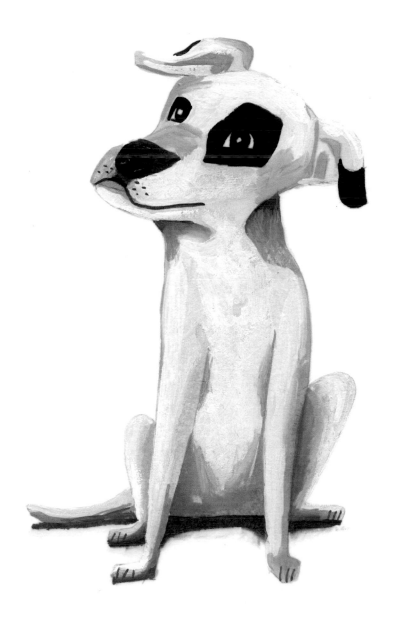

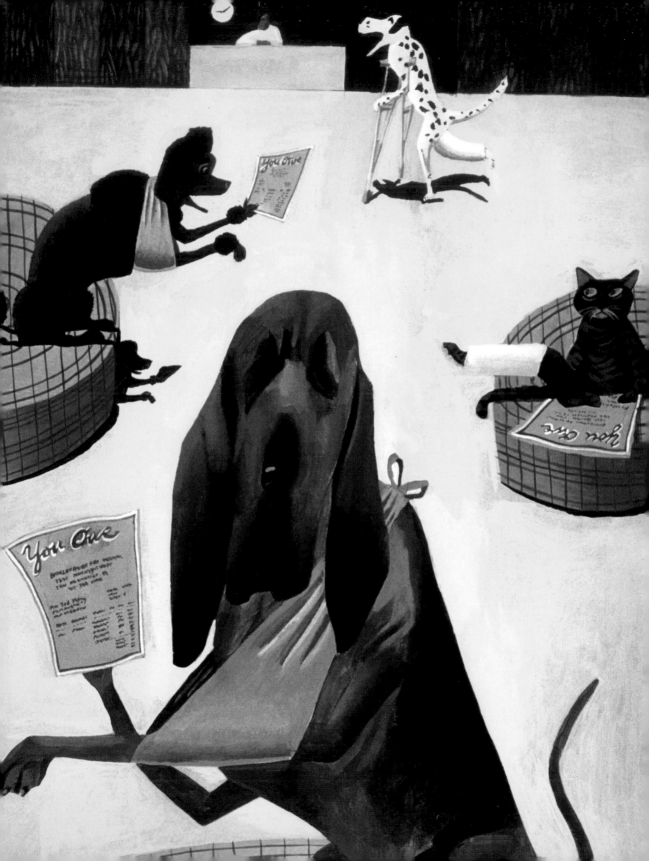

unfortunately, dogs can cost just as much as kids.

While kids eventually grow out
of that stage where they rush
to greet you every time
you walk in the front door,
thankfully dogs never do.

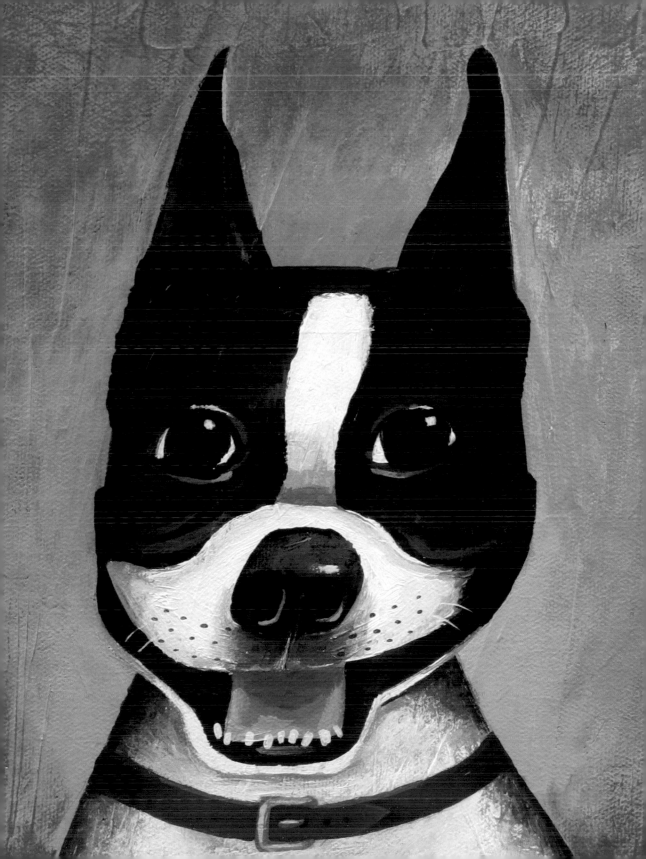

Long after the
kids are grown
and gone,
it's nice to know
that there will
always be a dog
in my life.

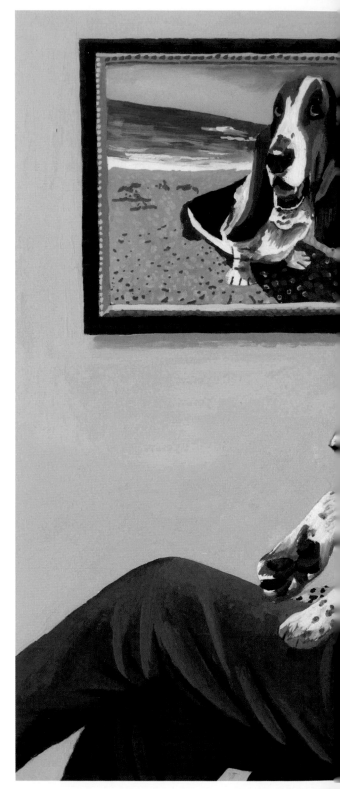

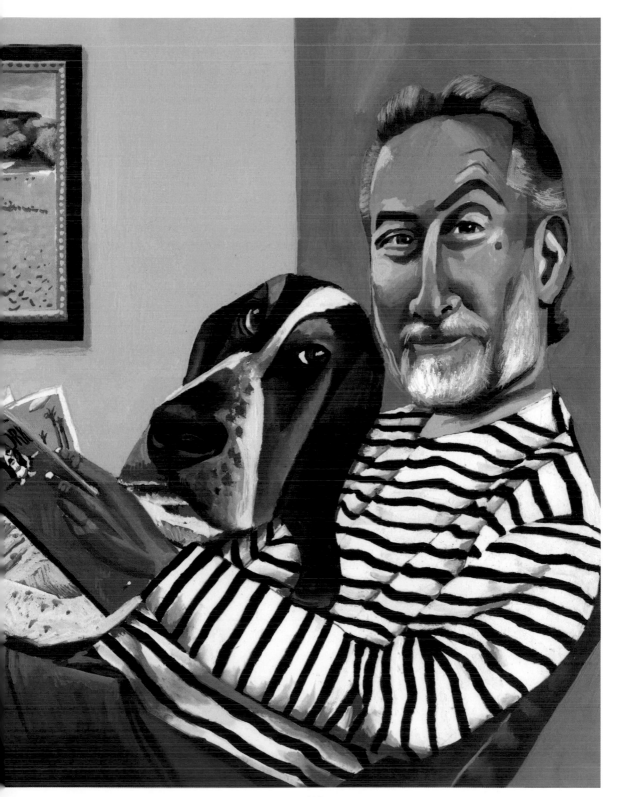

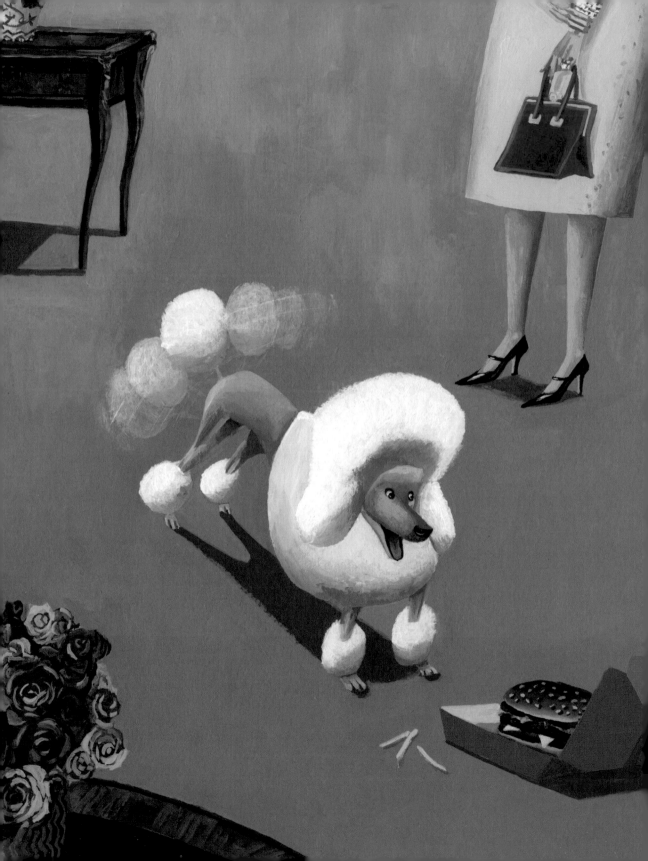

Dogs have such short lives.
They deserve to be spoiled.

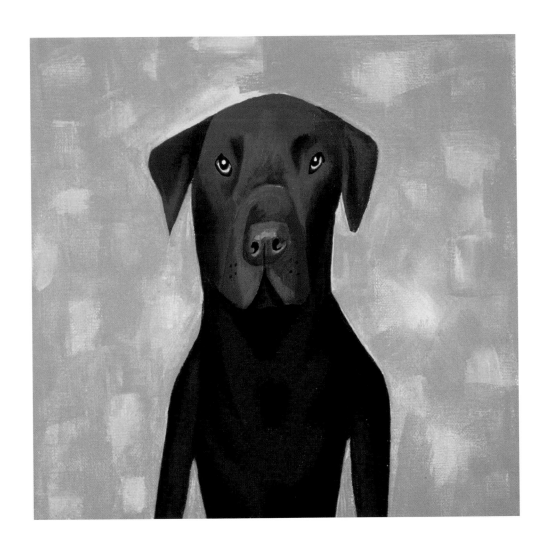

124

As TED grew old and feeble he became
more stoic. He had done all the
barking, fetching, scratching, licking,
scarfing, chasing, leaning, snuggling,
shedding, and drooling that
he was meant to do.
It was his time to move on.
He never whined or whimpered.

I cried for a week.

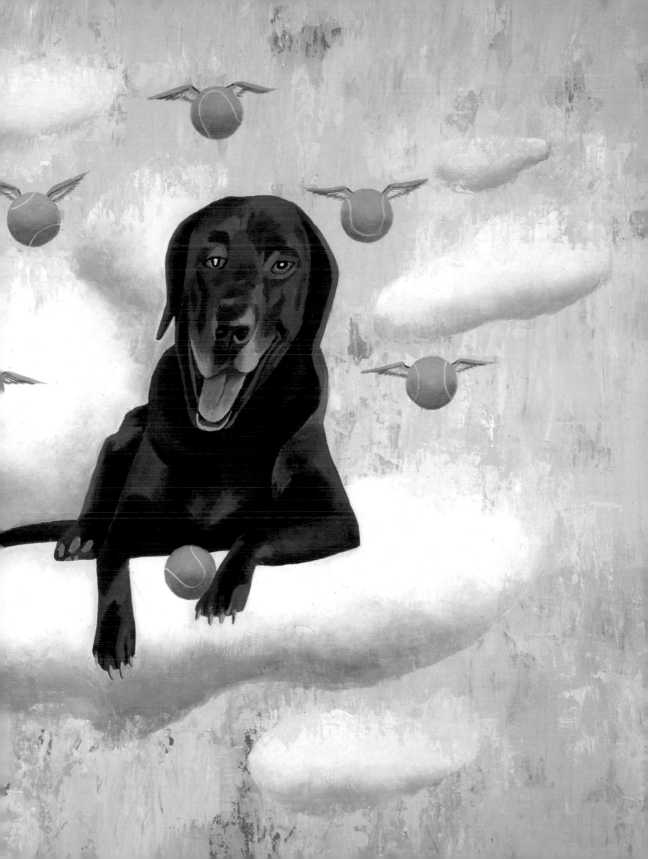

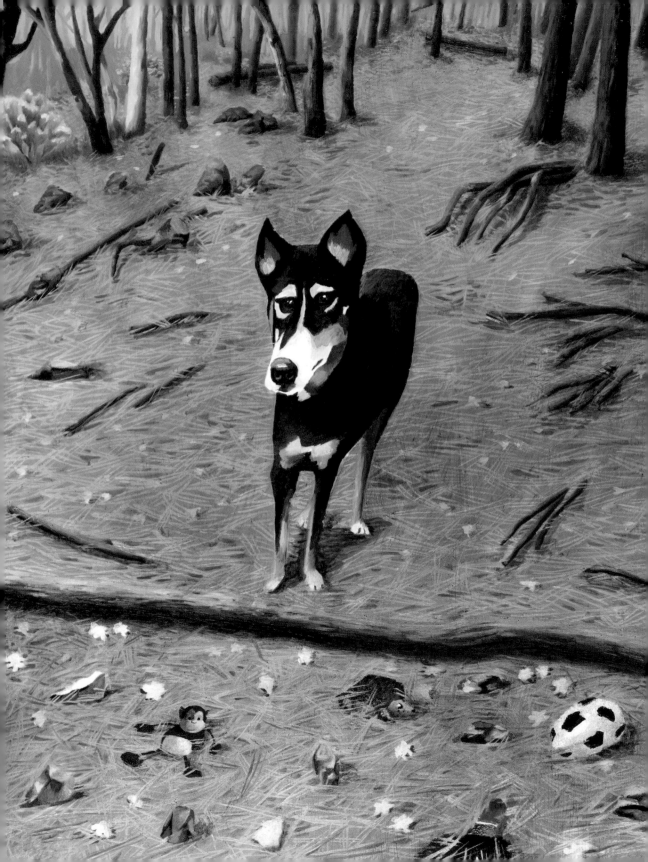

In the time it took our kids to finish grammar school our dogs' lives were already complete, as if they had accomplished all that they were put here to do.

A dog's life is filled with simple pleasures: playing, roaming, carousing, exploring, conquering and, most importantly, loving.

They do it all with vigor and gusto.

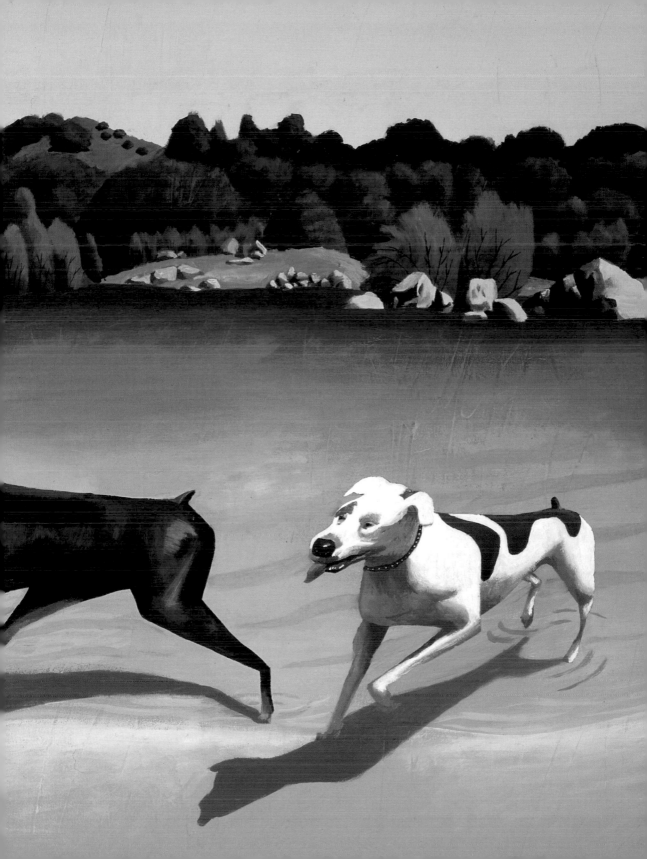

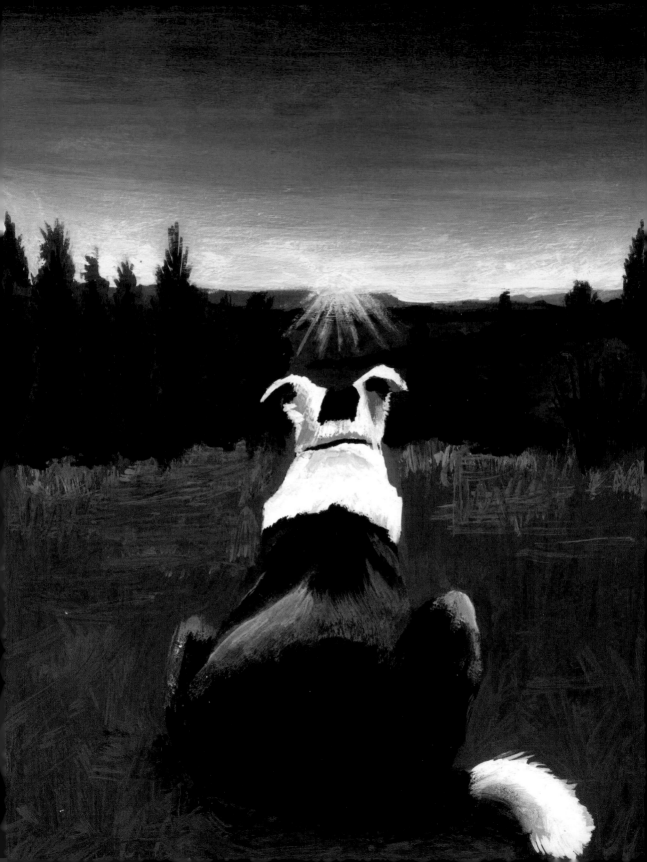

And for all of their
seemingly self indulgences,
they have no ego.
Which may explain
why a dog will never ask you
if its butt looks big.

And why they seem
to love you even more
than they love themselves.

Everything's better
with a dog.

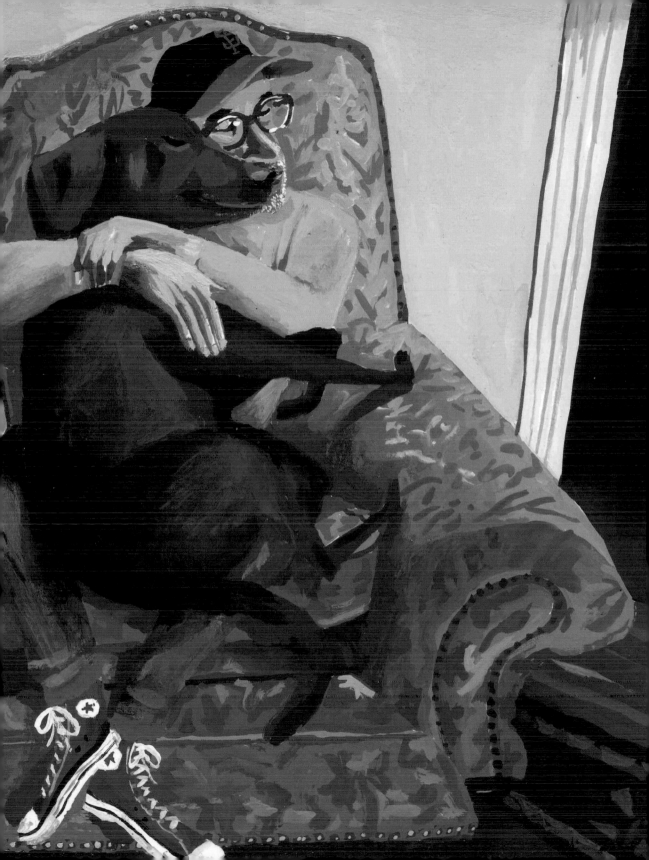

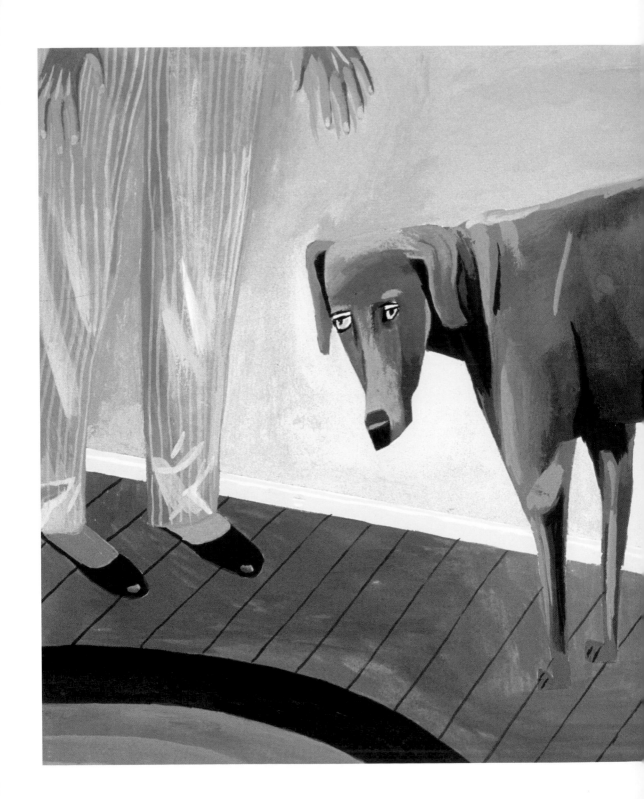

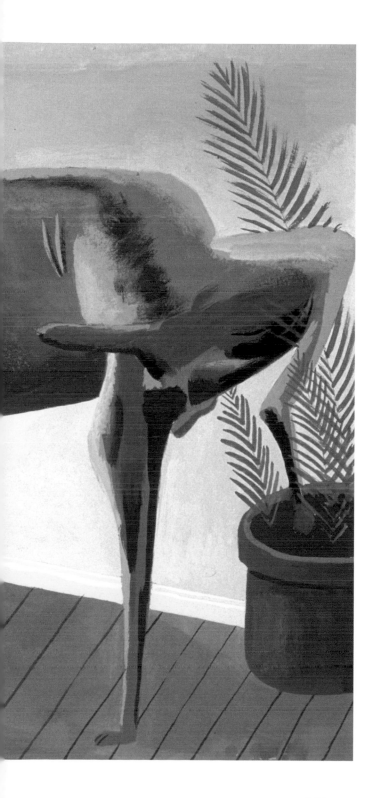

ultimately,
dogs rule.
Nonchalantly.

A Little Bit About the Author

"After college I worked as a publication designer for thirteen years. Once I became the art director of San Francisco Focus magazine, I became the boss, an administrator, a manager. It was no fun and I quit.

Around the same time I had a dream. I am going to bat in a baseball game. I grab a ruler to bat with and swing and miss. STRIKE ONE! I grab a t-square. I swing and miss. STRIKE TWO! I grab a third design tool, a plastic triangle and again I swing, only this time I foul the ball into the catcher's mitt, who drops it. I'm still alive! Then I grab a paint brush. I swing and POW! I hit a home run. I woke up laughing. That's when I decided I had better learn how to paint."

Mark Ulriksen wears his art on his sleeve. A successful illustrator, his work is regularly featured on the cover of The New Yorker and other popular publications, as book jackets, in art galleries and as commissioned work. His style is colorful, thoughtful and humorous. Mark's work has won multiple gold and silver medals from the Society of Illustrators and is in the permanent collection of the Smithsonian and the Library of Congress.

Timeline of the paintings

Henry
Dogs Rule, Nonchalantly
Gouache on paper, 2014

A Dog For Christmas
The New Yorker magazine
Gouache on paper, 1996

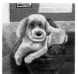

Maggie
Personal painting
Gouache on paper, 2012

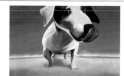

Little Dog
Thomas R Reynolds Gallery, SF
Acrylic on canvas, 1996

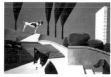

Alta Plaza Park, Dogs Only
Thomas R Reynolds Gallery, SF
Acrylic on canvas, 1995

Astro and Cisco of Silicon Valley
Private commission
Gouache on paper, 2012

Brady Dogs
Thomas R Reynolds Gallery, SF
Acrylic on canvas, 2000

Moose and Zuni
Private commission
Acrylic on board, 2005

Three Jacks
Private commission
Acrylic on canvas, 1997

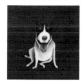

Happy Dog
Personal piece
Acrylic on canvas, 2001

The Dogs of My Life
Dogs Rule, Nonchalantly
Acrylic on board, 2013

Feed Fred
Dog Show, children's book
Acrylic on board, 2004

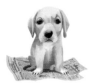

Grumpy Puppy
Personal piece
Gouache on board, 2010

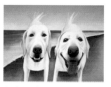

On the Beach
Private commission
Acrylic on canvas, 2006
Note: artisitic license was utilized turning these yellow Labs chocolate for the narrative flow.

Henry is Fussy
Dogs Rule, Nonchalantly
Gouache on paper, 2014

Tiger, the Giants Fan
Private Commission
Acrylic on canvas, 2008

Hot Dogs
The New Yorker magazine
Acrylic on board, 2007

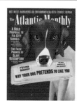

Why Your Dog Pretends to Like You
The Atlantic Monthly magazine
Gouache on paper, 1999

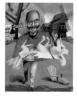

Scott and Mick
Private Commission
Gouache on paper, 2013

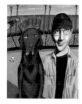

Ted and Mark at Pac Bell
Thomas R Reynolds Gallery, SF
Acrylic on board, 2000

Hoop Star
Bark magazine
Acrylic on board, 2001

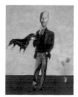

My Dog Bite
GQ magazine
Acrylic on paper, 1997

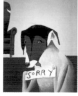

Sorry
The Atlantic Monthly magazine
Goauche on paper, 1999

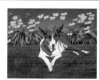

Scout of Denver
Private Commission
Acrylic on canvas, 2001

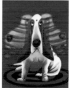

Fred Says No
The Biggest Parade
Children's book
Acrylic on paper, 2006

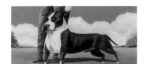

Bully
Wurst Gallery, Portland, OR
Acrylic on canvas, 2006

Harvey and Fred
Dog Show, children's book
Acrylic on board, 2004

Season of Surprises
The Washington Post Magazine
Acrylic on board, 2002

Urban Legend
*The Completely and Totally
True Book of Urban Legends*
Acrylic on paper, 2001

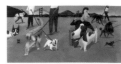

The Whole Town Turned Out
Dog Show, children's book
Acrylic on board, 2004

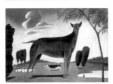

Hybrids
The Atlantic Monthly magazine
gouache on paper, 1999

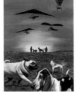

Fort Funston
San Francisco Arts Commission's Art
on Market St. program
Egg tempera on board, 2013

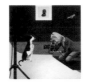

Amanda at Work
Private commission
Acrylic on canvas, 2006

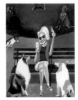

Pizza Dogs
The Walking Magazine
Gouache on paper, 2001

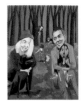

**Boy Meets Girl Meets
Dogs**
The Walking Magazine
Gouache on paper, 2001

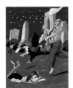

Spring Fever
The New Yorker magazine
Acrylic on paper, 1995

In the Wee Small Hours
The New Yorker magazine
Acrylic on paper, 1997

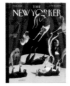

Dog Show
The New Yorker magazine
Acrylic on paper, 2002

Here They Come
Dog Show, children's book
Acrylic on board, 2004

McIver
Private Commission
Acrylic on paper, 1992

Sally of Baltimore County
Washington Post
Acrylic on board, 2011

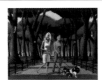

**Donna and Allegra in
Central Park**
Private Commission
Acrylic on canvas, 2006

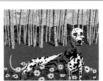

Chili of Maine
Private Commission
Acrylic on canvas, 2007

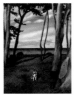

Rocky in Pacific Grove
Private Commission
Gouache on paper, 2012

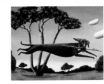

Dinah of Glen Ellen
Private Commission
Acrylic on canvas, 2007

Puppy Love
The New Yorker magazine
Acrylic on board, 2001

The Park
Bark magazine
Gouache on board, 1999

Ball Hog
Personal piece
Acrylic on canvas, 1996

Willie, Christmas Card
Private Commission
Acrylic on board, 2001

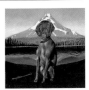

Moab
Private Commission
Acrylic on canvas, 2003

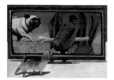

Dog-on Television
O, The Oprah Magazine
Gouache on paper, 2005

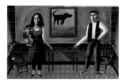

Family Portrait
Personal piece
Acrylic on canvas, 1993

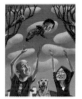

Alon, Susan, Olivia and Dexter
Private Commission
Acrylic on canvas, 2010

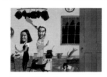

Kitchen Millionaires
Worth Magazine
Acrylic on paper. 1996

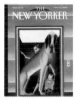

Three's a Crowd
The New Yorker magazine
Egg tempera on board, 2003

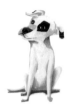

Teen
Personal Piece
Gouache on paper, 2005

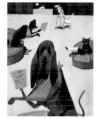

Pricey Pets
Readers Digest
Acrylic on board, 2003

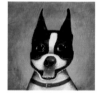

Lily's Dog
Personal piece
Acrylic on canvas, 2006

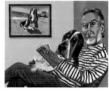

Mark and Archie's
Private Commission
Gouache on paper, 2012

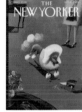

The Food Chain: Lucky Dog
The New Yorker magazine
Acrylic on board, 2009

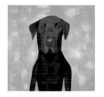

Ted
Personal piece
Acrylic on canvas, 2000

Ted in Heaven
Heaven/Hell Exhibition
Philadelphia Sketch Club
Acrylic on wood, 2003

Izzy, From the Other Side
Private Commission
Oil on panel, 2012

Hudson and Davina
Private Commission
Acrylic on canvas, 2005

Luke in Healdsburg
Dogs Rule, Nonchalantly
Gouache on paper, 2014

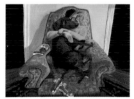

Henry and Me
Dogs Rule, Nonchalantly
Gouache on paper, 2014

Dogs Rule, Nonchalantly
The Atlantic Monthly magazine
Gouache on paper, 1999

Thank You

I wish to thank the following individuals who have been instrumental in helping to bring this book to fruition.

First and foremost thanks to Tom Walker, not only a friend of over 30 years (yikes), and old college roommate, but the main driving force behind getting this project off the ground and the strong hand steering me through my first writing effort.

My wife and best friend Leslie Flores, whose critical eye, sound advice and patience have served us both well for 33 years and counting.

To my daughters Emma and Lily, who share my love of life (and dogs) and to my agent Amy Rennert, a friend and colleague since our days working together at San Francisco Focus magazine many, many years ago. Her wisdom and encouragement are greatly appreciated.

Finally I'd like to thank my dear friend Alix Smith, who just may be more crazy about dogs than I am.

GOFF BOOKS/ORO EDITIONS
Copyediting by: Ryan Buresh
Project coordinator: Alexandria Nazar
color separations and printing: ORO Group Ltd.